IMAGES
of America

CAMARILLO

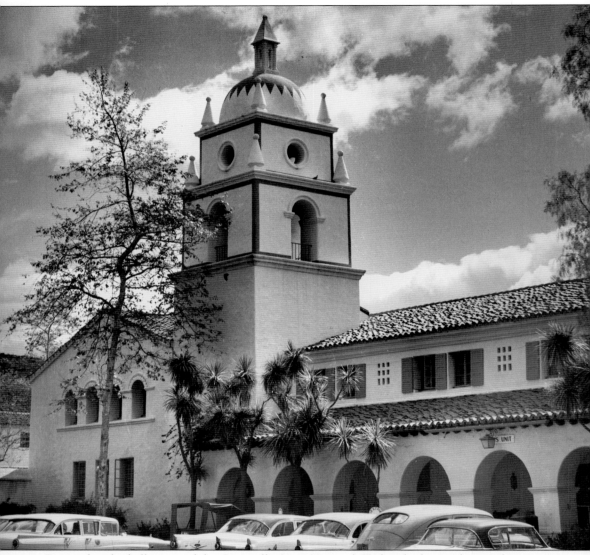

Pictured is the bell tower of the Camarillo State Hospital. Today the hospital grounds serve as the home to California State University at Channel Islands.

ON THE COVER: The Camarillo White Horses take part in the Santa Barbara Fiesta in 1953. Riders, from left to right, are Paquita Burket Parker, Rose Lopez, Helen Borchard, Carmen Camarillo, Claire from Sacramento, and Arcadia McDermott.

IMAGES
of America
CAMARILLO

Jeffrey Wayne Maulhardt

ARCADIA
PUBLISHING

Published by Arcadia Publishing
Charleston SC, Chicago IL, Portsmouth NH, San Francisco CA

Printed in the United States of America

Library of Congress Catalog Card Number: 2006924386

For all general information contact Arcadia Publishing at:
Telephone 843-853-2070
Fax 843-853-0044
E-mail sales@arcadiapublishing.com
For customer service and orders:
Toll-Free 1-888-313-2665

Visit us on the Internet at www.arcadiapublishing.com

This book is dedicated to my great-aunts and uncles who served as inspirations and models for me: Flo and Eddie Maulhardt, Jeanne and John Maulhardt, and Ruth and Richard Maulhardt.

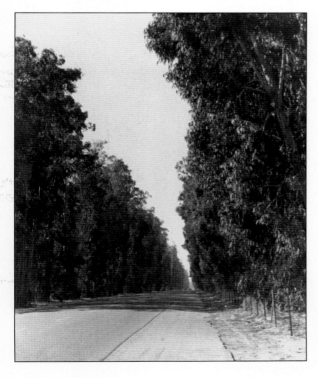

Adolfo Camarillo planted rows of eucalyptus in front of his residence and along the Old Conejo Road in 1890 with the help of several Chumash Indians employed by Camarillo.

CONTENTS

ACKNOWLEDGMENTS

The photographs in this volume were made available due to the generous efforts of many people and a few organizations. This volume is a representation of the available photographs. If I had a choice between using a photograph that appears in other Camarillo publications or an unpublished photograph, I chose the relatively unseen photograph. However, in some cases, it made sense to use the familiar photograph. Nonetheless, I feel this is a nice complement to the previously published Camarillo books.

I truly appreciate the invaluable help and input from the many people who helped make this book possible. First and foremost, thanks to my good friend Eric Daily. Eric has always contributed to my books, but this time he supplied more than just photographs; he came through in emergency situations with that extra photograph, that needed identification, and that last-minute delivery.

Thank you to the friendly people of the Pleasant Valley Historical Society. Every community needs an organization as dedicated in helping preserve the history of the community. Also thanks to the Camarillo Ranch Foundation and Kristin Richey-Herrera for the life-saving generosity in allowing me to scan photographs used in this publication.

Meliton Ortiz was hospitable enough to share his historic photographs and entertaining stories. Thanks to Dr. Robert Colbern for introducing himself to me and for allowing me to borrow his research and photographs related to the Camarillo State Hospital. The energetic efforts of Mary Caroline Chunn are much appreciated, as well as those of Adele Flynn Walsh. Thanks also go to Gary Blum, Liz Daily, Stan Daily, Barbara Fulkerson, Bob Fulkerson, fellow Arcadia author Glenda Jackson, Craig Held, Robert Hernandez, Betty Culbert Powell, and Joe Ortiz. A final thank you goes out to Paul Wilvert for filling in the gaps and providing me with last-minute scans.

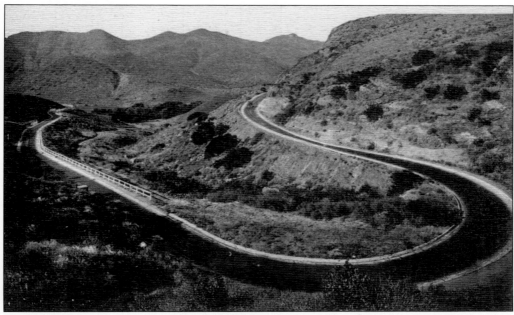

The Conejo Grade is pictured here in the 1930s.

INTRODUCTION

The history of the Camarillo area has its roots in several ranchos. The central portion of Camarillo is located on a triangular piece of land a bit larger than 1,000 acres. It was once government land, bounded on the north by Rancho Las Posas, on the east by Rancho Calleguas, and on the south by Rancho El Rio de Santa Clara o la Colonia and Rancho Guadalasca.

The first town site in the area was Springville, and it existed for 25 years before the town of Camarillo. Springville was located on the northeast end of Rancho Colonia and today is referenced as being located on the south side of Highway 101 near the Camarillo Airport.

The original town site was part of 92 acres farmed by John Sebastian. A post office was established in 1875. In 1879, Sebastian grew 60 acres of barley and 120 trees of mixed varieties. He also grew sweet and Irish potatoes. The *Ventura Signal* on January 4, 1879, announced, "Springville possesses a better outlook than almost any other part of the county." One reason for such a claim was the formation of the Santa Clara Water and Irrigation Ditch Company, which diverted water from the Santa Clara River through the middle of Springville. With the abundance of water, the area had a bright future.

By 1880, Springville consisted of two mercantile stores; a restaurant run by S. Rogers; two feed stables, one run by John Wilson and another by T. G. Riggs; a school; church; hotel operated by Mrs. N. Wilson; tavern; and Sebastian's blacksmith shop. A stagecoach service stopped at the town up until 1887, when the railroad through Saticoy made the stop unnecessary. William O. Wood was instrumental in establishing a Baptist church, as well as the Springville School.

With the construction of the rail line a few miles east of Springville, a new town followed. The first business to leave was the Sebastian store. The Willard family had lived in the expanded Ruiz Adobe when it burned down, and they relocated near the new Sebastian store. The modest, wooden structure served as the Willards' new home and as a hotel for the railroad workers and passersby. The name Calleguas was submitted for the name of the new railroad stop, but it was rejected. Then the Camarillo name was submitted and accepted. As the town of Camarillo grew, the town of Springville began to look more like a ghost town. The farmers stayed, but they took their business to Camarillo or to anther new town, Oxnard. The school remained but was rebuilt in 1930.

Slowly businesses opened up near the new railway stop. The Camarillo Depot building was completed in 1906. The Fulton Hotel was also established during this time, as was the Murphy and Weil mercantile store, later sold to Meyer and Adams. The Buckhorn Saloon and Café and Ike Norman's blacksmith shop opened during the first decade. By 1914, the beautiful Mary Magdalene Chapel was complete. By 1915, Joseph Lewis began construction on a block of buildings that served as the home for various businesses throughout the years. Andrew Cawelti also built a string of buildings at the corner of present-day Ventura Boulevard and Lewis Road. Both the Cawelti and Lewis buildings remain in use today.

In 1910, William Fulton mapped out a housing tract to the north of the town, near present-day Barry Street. By 1916, several homes had been built. The next residential expansion did not occur until after World War II. The Pleasant Valley tract homes were built on the south side of Ventura Boulevard. The Arneill tract, "Raemere," northeast of Barry Street, was built between 1953 and 1956.

The freeway construction in 1954 changed the flow of the town. The main street in Camarillo was part of the Old Conejo Road. After the highway was constructed to the north of town, present-day Ventura Boulevard was established. Several houses were moved and others were destroyed. The families affected by the new highway were those of Lawrence Brinkerhoff, John Conrad, Ed Fulton, Ed Hayes, Israel and Irene Hernandez, and Lena Jones. Some of the homes have survived into the next century.

Beyond the town of Camarillo, the agricultural community thrived. Like any farming endeavor, there were good years and bad years. However, with the introduction of new crops, farmers of the

Pleasant Valley adapted and survived. After a reduction in cattle and sheep ranching during the drought years of the early 1860s, dry farming became the first industry to develop. Wheat, barley, and corn were the top three crops. Michael Flynn is said to be one of the first to plant lima beans on the south side of the river. Adlofo Camarillo followed, as did Joseph Lewis, whose family planted the first lima beans in Carpentria several decades previous, before Lewis bought over 8,000 acres of Rancho Guadalasca.

Juan Camarillo came to California in 1834 as part of the Hijar party from Mexico. By the 1850s, he was living near Mission Buenaventura. He purchased portions of the Rancho Calleguas from the Ruiz family in 1875 and 1876. Jose Pedro Ruiz was the grantee of 9,998.29 acres of the Rancho Calleguas in 1837. Calleguas means "burial ground," and before Ruiz was granted the land, the Chumash Indians had traveled across it for centuries. In 1880, Juan Camarillo died, only a few years after he acquired the land. His 16-year-old son Adolfo met the challenge of developing the rancho, which he did for the next 78 years.

The Daily brothers were another important family in the history of Camarillo. Charles J. Daily was the first to arrive in Ventura County in 1885 from New York. He worked on the 6,000-acre Patterson Ranch near Hueneme. Quickly rising to the position of foreman, Charles was joined on the Patterson Ranch by his father and brothers over several years. Soon the brothers purchased tracts of land in the Pleasant Valley area. Charles J. Daily bought a 63-acre parcel in the Springville area in 1891 from Caroline Butts. Within a few years, Daily had purchased 400 acres in the Camarillo area. Erastus Wright Daily and Wendell Daily bought ranches in the vicinity. By 1901, the Daily brothers were reunited in the Camarillo area. Later generations of Dailys continue to contribute to the community.

Other families that were farming in the Camarillo area in the late 19th and early 20th centuries included the Arneill, Cawelti, Clark, Coultas, Gerry, Alexander Gill, Alfred Hartman, J. C. Hartman, Clint Hutchins, William Fulton, George Glenn, the Gisler brothers, Hughes, Livingston, Mahan, L. G. Maulhardt, McGrath, David Perkins, John Saviers, Smith, Scholle, Vacca, Wood, and Wucherpfenning.

A portion of the Joseph Lewis ranch, 1,650 acres, was sold to the State of California for the purpose of building a mental health facility. By 1936, the Camarillo State Hospital received its fist patient. A farm was established on-site to provide food and milk for the hospital population. The hospital not only supplied mental health services for hundreds of thousands of residents during its 50 years, it also supplied thousands of jobs and cared for as many as 1,800 people at one time. The cost of $144,000 a year per patient caused the facility to close in the spring of 1997. The California State University lobbied to acquire the land and buildings and, by 1999, the university system was given a Preservation Award for conservation and reuse of the architectural treasures. The university was also given a financial jump-start with multimillion-dollar donations from local entrepreneurs Robert Largomarsino, Jack Broome, and the Martin V. Smith family. Broome's $5 million donation helped establish the Jack Spoor Broome Library. The Smith family's $8 million donation established the Martin V. Smith School of Business and Economics.

By the early 1960s, a movement was started to incorporate the growing town of Camarillo. With incorporation, would come better police protection, a sanitation system, improved roads, and autonomy from being annexed by another city. A 5.4-square-mile boundary was carved out. A 64 percent turnout at the polls brought an overwhelming victory for incorporation—1,900 votes in favor, 353 against. Earl Joseph brought in the highest number of votes for city council and was appointed Camarillo's first mayor. Other charter council members included Stanley Daily, Ned Chatfield, Guy Turner, and Edith Tweedy Camarillo Rouce.

In a little over 40 years, the population has risen to over 60,000 residents, and the area of the city has expanded to 20 square miles. Despite the growth that has overburdened many Southern California cities with accompanying development and overcrowding, Camarillo has remained a desirable place to live. It is a city adage that those who come, do not want to leave.

One

THE RANCHOS

LAS POSAS, CALLEGUAS, AND EX MISSION

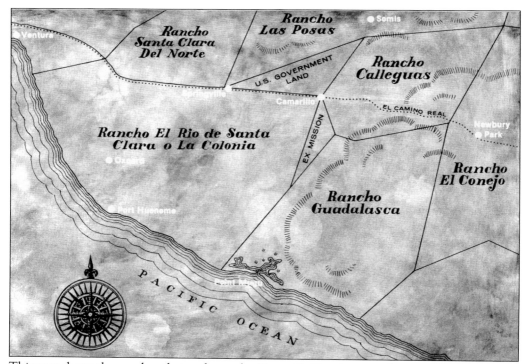

This map shows the ranchos that make up the Camarillo/Somis area—the northeastern portion of Rancho El Rio de Santa Clara o la Colonia, Rancho Las Posas, Rancho Calleguas, and the U.S. government land that was homesteaded by some of the early setters of the area.

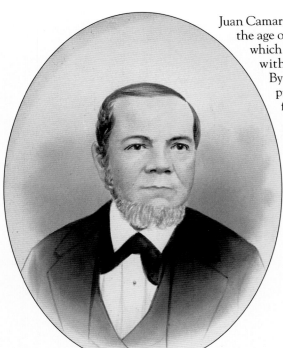

Juan Camarillo was born in 1812 in Mexico. In 1834, at the age of 22, he traveled with the Hijar Expedition, which consisted of 200 men, women, and children, with skills in every trade except farming. By the time they arrived in San Diego, the promise of free land and 50 *centavos* a day from Governor Figueroa of California had vanished. Camarillo made his way to the mission in Santa Barbara where he soon began a merchandise store. He moved to San Buenaventura by 1857.

Martina Hernandez Camarillo was the daughter of the administrator of Mission San Luis Rey and the granddaughter of Jose Francisco Ortega, an officer for Gaspar de Portola who is credited with the discovery of the San Francisco Bay on behalf of the Spanish. She married Juan Camarillo in 1841, and they had 14 children. (Courtesy Pleasant Valley Historical Society.)

Pictured are classmates Bruce A. Leach, standing, and Aldofo Camarillo. Adolfo graduated from Woodbury Business College and went on to successfully manage the Camarillo's 10,000-acre ranch. Leach arrived in San Buenaventura in 1866 and became the "village plumber," as well as bandleader for the Ventura Band.

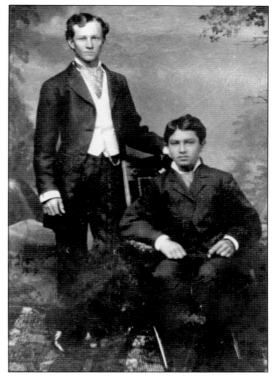

The last male to carry on the Camarillo surname was Frank "Poncho" Camarillo (1896–1952), pictured here honing his riding skills. Frank married Tweedy Rouce. The couple did not have any children, and the Camarillo legacy was carried on through the children of his sisters—Isabella, Ave Maria, and Rosa Avelina. (Courtesy Camarillo Ranch Foundation.)

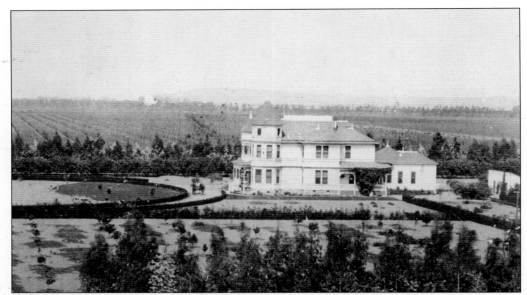

Juan Camarillo purchased the Rancho Calleguas property from the Ruiz family in 1875 and 1876. Camarillo died in 1880, and his young son Adlofo, then 16, took on the responsibility of running the rancho. Adolfo graduated from Woodbury College in 1884 and married Isabella Menchaca in 1888. By 1892, Camarillo built a three-story, 14-room, Queen Anne Victorian–style home. This photograph was taken around 1895.

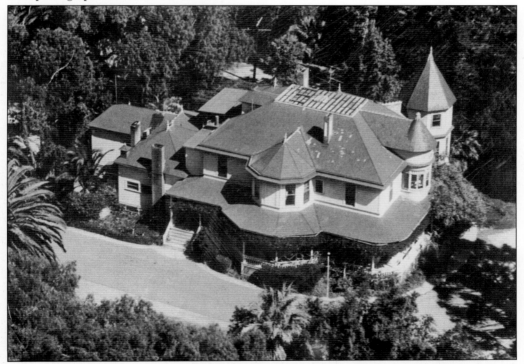

The Adolfo Camarillo house was designed by architects Herman Anlauf and Franklin Ward. (Courtesy Camarillo Ranch Foundation.)

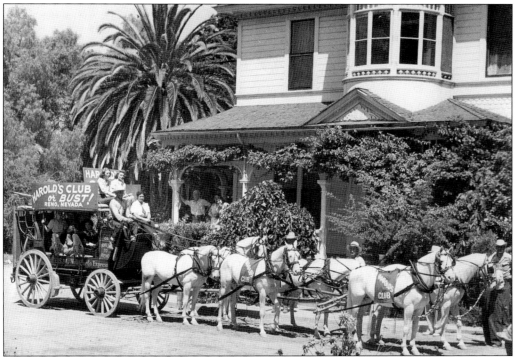

Over the years, the Camarillo house has served as the backdrop to many different types of get-togethers, including this promotion for Harold's Club in Reno, Nevada. In this photograph, Carmen Camarillo takes a seat next to the driver. Longtime Camarillo employee Meliton Ortiz stands behind the first set of horses.

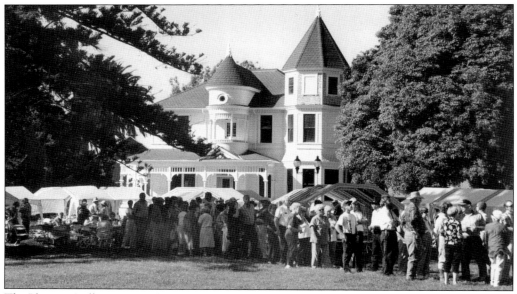

The Pleasant Valley Historical Society has continued the old California tradition of recognizing the contributions of community leaders by awarding deserving honorees "Don and Doña" status. The society conveyed such honors on the front lawn of the Camarillo Ranch Foundation in 2000.

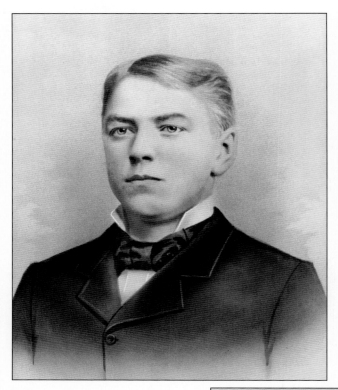

Joseph Lewis was born in Carpenteria in 1863. As a young boy, he helped his father, Henry Lewis, plant the first crop of lima beans on their hillside ranch in Santa Barbara County sometime after 1868. Surprisingly, despite unnecessarily irrigating the beans, the plant prospered. After years of perfecting the lima bean, it made its way to Ventura County, where it became the number-one crop.

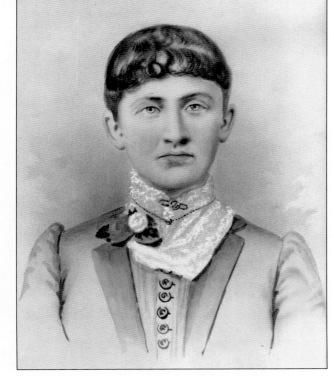

Sarah Richardson Lewis raised six children—Guy; Searles; Joseph Jr.; Alma, who married Fred Stein; and Lulu, who married Terence F. Tally. Stein and Tally joined forces and opened a department store off Ventura Boulevard.

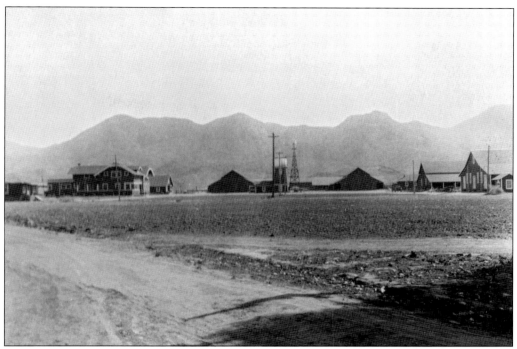

This view shows the Lewis Ranch on Rancho Guadalasca with a backdrop of the Santa Monica Mountains. Joseph Lewis relocated to Ventura County in 1899 and leased 260 acres of Rancho Calleguas. For a short time, he went into business with Adolfo Camarillo in a joint farming venture.

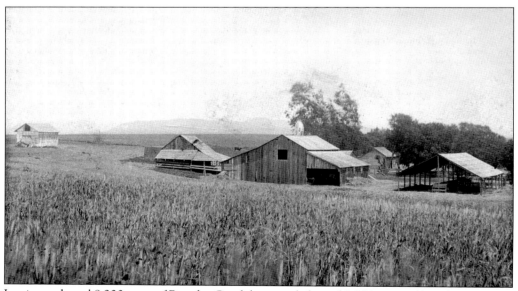

Lewis purchased 8,200 acres of Rancho Guadalasca and planted 2,000 acres of lima beans, 1,000 acres of hay, and eventually 900 acres in walnuts. A portion of the ranch was later sold to make room for the Camarillo State Hospital. (Courtesy Pleasant Valley Historical Society.)

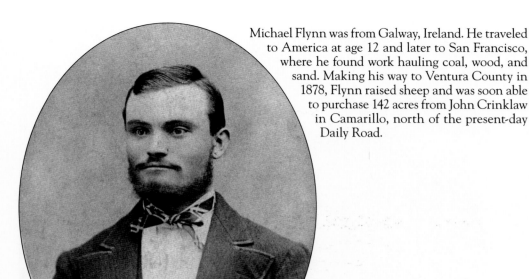

Michael Flynn was from Galway, Ireland. He traveled to America at age 12 and later to San Francisco, where he found work hauling coal, wood, and sand. Making his way to Ventura County in 1878, Flynn raised sheep and was soon able to purchase 142 acres from John Crinklaw in Camarillo, north of the present-day Daily Road.

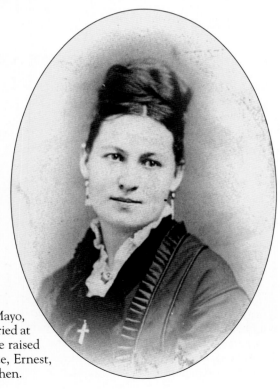

Sarah Lavelle Flynn was born in County Mayo, Ireland. Sarah and Michael Flynn were married at the San Buenaventura Mission in 1879. She raised nine children—David, Robert, Mary Grace, Ernest, Clarence, Sarah, Adolphe, James, and Stephen.

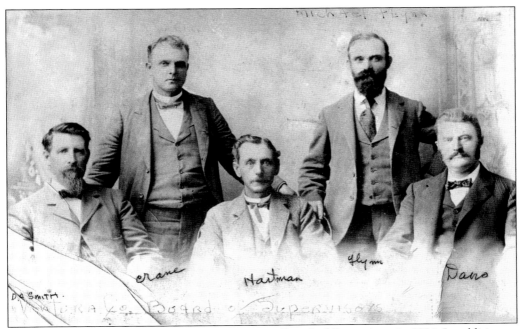

Michael Flynn was elected to the Ventura County Board of Supervisors in 1894. In addition to being among the first to plant lima beans on the south side of the Santa Clara River, Flynn is said to be the first to plant large acreage in walnuts, which became a top agricultural industry in Ventura County for several decades. Flynn was also instrumental in pushing for the original bridge across the Santa Clara River. Pictured, from left to right, are Dan Smith, Emmett Crane, Fridolyn Hartman, Michael Flynn, and Frank Davis.

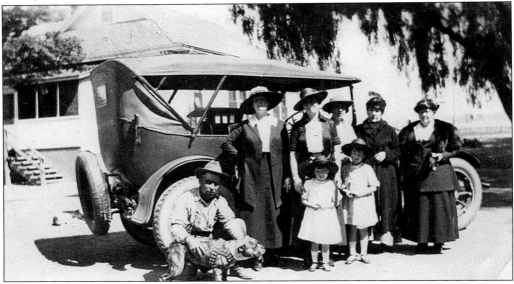

The Flynn family gets ready for a Sunday drive. Pictured, from left to right, are David Leo Flynn, Mae Manning, Mae Flynn (Jones), Nellie "Birdie" Flynn Kimball, Nellie Gilligan Flynn, and her sister. The Manning girls are in front. (Courtesy Mary Caroline Chunn and Adele Flynn Walsh.)

Juan Camarillo, Adolfo's brother, spent many years traveling to Europe and South America. Beginning in 1916, he made his home in Buenos Aires for many years, but not until after he had overseen the construction and completion of the St. Mary Magdalen Chapel in 1914.

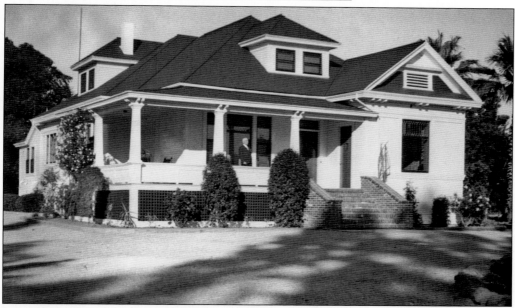

Juan Camarillo had this house built near present-day Flynn Road. He made several return visits to the area, and each visit was accompanied with a large celebration given by his brother Adolfo. The 1924 visit included 750 guests. The Israel Hernandez family lived on the property and kept things in order while Juan was away. (Courtesy Bobby Hernandez.)

Sarah Jane Saviers, daughter of John Young Saviers, was 16 years old when she married Josiah Willard; they raised 10 children. The Willards came to the Camarillo area in 1885.

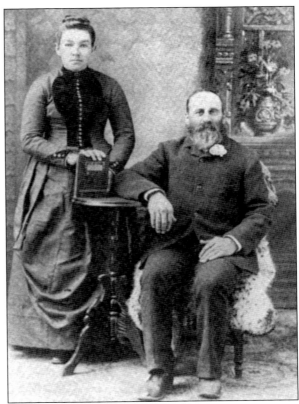

The Willards stayed in the Ruiz adobe on the Camarillo Ranch for seven years before building a home near Ventura Boulevard and Lewis Road. The house served as an overnight stop and a resting point for stagecoach travelers.

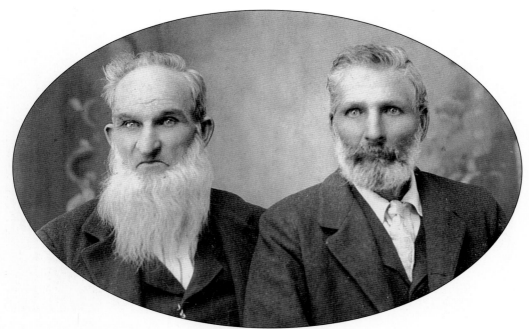

In 1869, George Washington Hughes, left, and William A. Hughes came to Pleasant Valley. William was born in Pennsylvania, moved to Illinois with his parents, and, by 1864, joined a wagon train and traveled to Marysville, the Red Bluff, and finally Pleasant Valley.

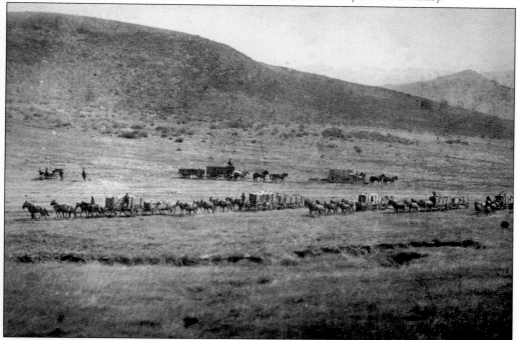

Wagon trains of wheat, barley, and corn traveled from Simi Valley through the Las Posas Valley on their way to the wharf in Hueneme. Hughes could hear the approaching wagons as they rumbled through the valley.

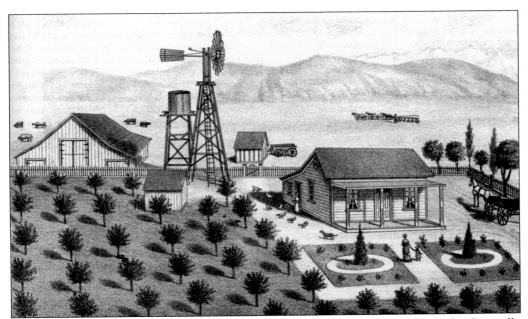

Hughes homesteaded 160 acres of government land that was located between present-day Camarillo and Somis. The above photograph is taken from the 1883 Thompson and West publication. Idealized drawing was typical of the depictions from the book.

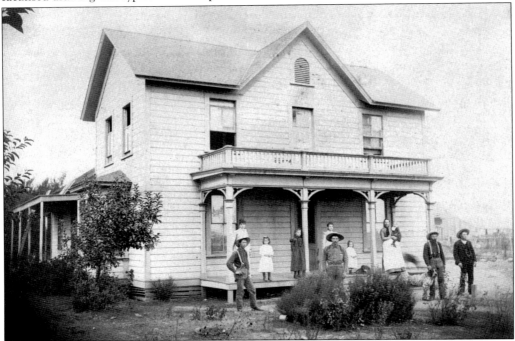

This photograph of the Hughes residence shows the room additions to the original home. The men in the photographs, from left to right, are Bill, John, William, and George. The ladies, from left to right, are Fannie, Blanche, Ethel, Mae, Pearl (holding Harry), and Mary Barnett Hughes. (Courtesy Betty Culbert Powell.)

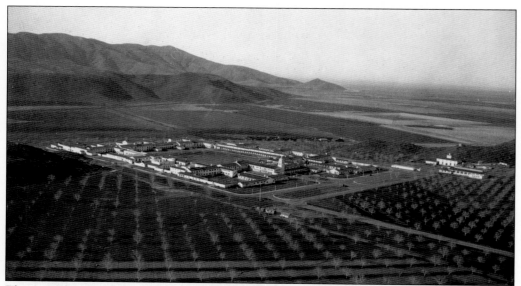

The state built the Camarillo State Hospital on 1,650 acres of the Joseph Lewis Ranch. Constructed in 1932, the hospital received its first patient in 1936.

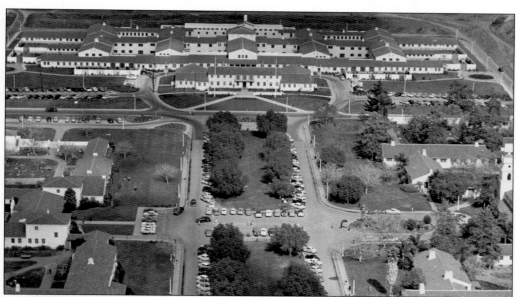

At one time, the resident population at the hospital reached 7,000. The advent of tranquilizers and advances in psychiatric treatment reduced the patient roll to 1,600 in the 1960s. As many as 1,800 people were employed at the hospital during this time.

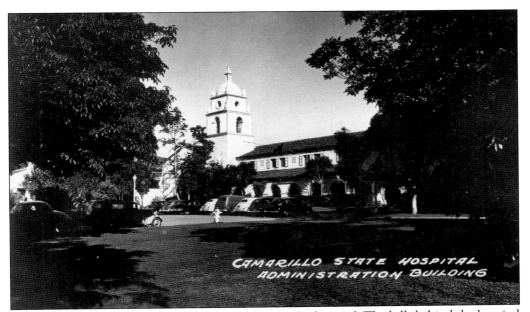

A farm at the site provided the milk and produce for the hospital. The hills behind the hospital were used in the 1970s to film episodes of the television series *M*A*S*H*.

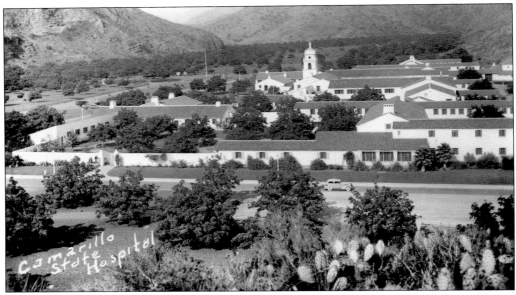

The hospital closed its doors in 1997. In 2002, it reopened as California State University, Channel Islands, making it the 23rd campus in the California State University system.

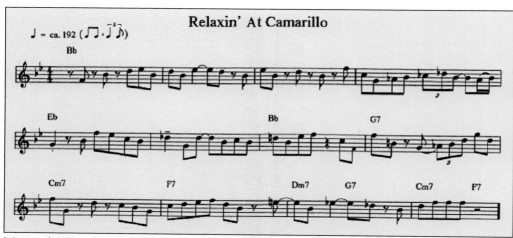

Relaxin' At Camarillo

Many celebrities have passed though the rehabilitating halls of the hospital. Among the graduating residents in 1947 was legendary jazz saxophonist Charlie Parker. Parker emerged from his six-month stay to compose his homage to the place, *Relaxin' at Camarillo*. Many artists have covered the tune over the years, including Joe Henderson in the 1990s.

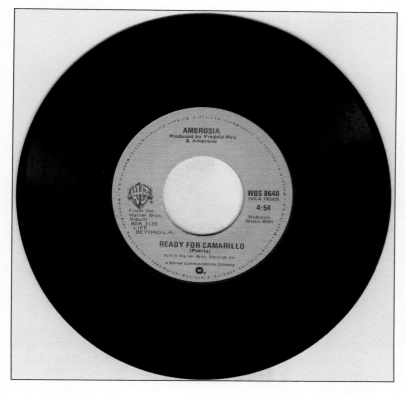

The 1970s rock group Ambrosia penned this tune for the well-known hospital. Some people have proposed the theory that the Eagles' 1970s song "Hotel California" was written in reference to the mental hospital, specifically referring to the line, "You can check in anytime you like, but you can never leave." The album cover even has the same Spanish-style architectural theme, even though it is known to have been photographed at the Beverly Hills Hotel.

Not all songs about Camarillo refer to the mental institution. This page presents two versions of the sheet music for the "Camarillo March," written by L. Sansone in honor of the big barbecue tendered by Juan E. Camarillo. The date is listed as September 9, 1907, and this image shows the Juan E. Camarillo home. (Courtesy Museum of Ventura County.)

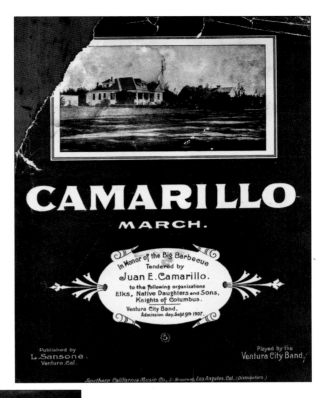

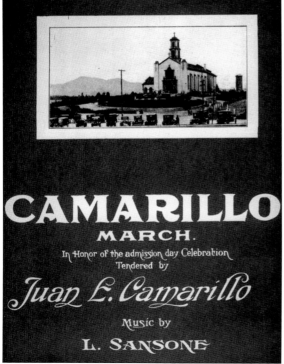

This second version of the "Camarillo March" is from the Robert Hernandez collection. It was reproduced in October 1989 in celebration of the 25th anniversary of Camarillo's cityhood. This image displays the Mary Magdalen Church in the 1920s. Juan returned for a visit in 1924, and this may have been the origin of the second sheet music. Hernandez's family lived at the ranch.

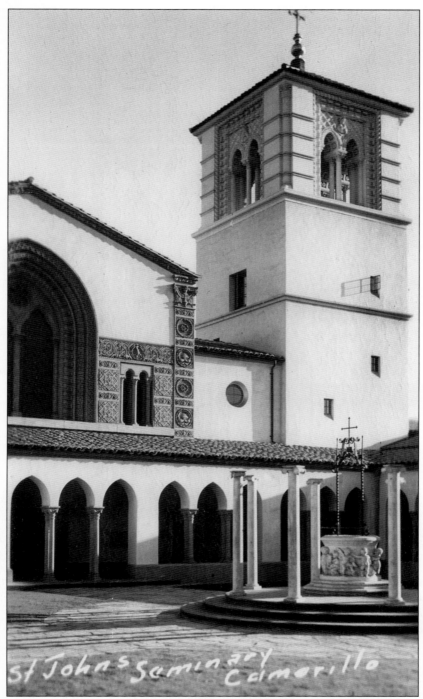

St Johns Seminary Camarillo

The St. John's Seminary is located on 100 acres donated by Juan E Camarillo. The buildings were completed in 1939, and the first term had 67 students enrolled to begin their studies for the priesthood. A library, built through a donation from Estelle Doheny and dedicated to her husband, Edward Doheny, contains over 8,000 volumes of rare books.

Two

PLEASANT VALLEY

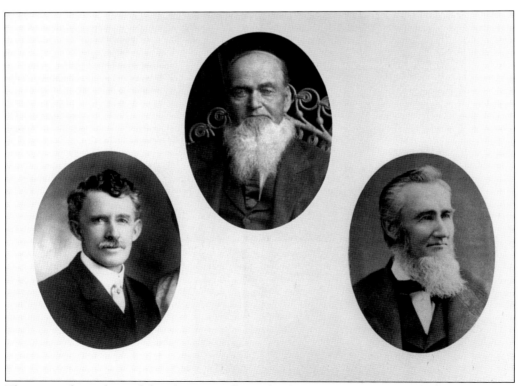

The original members of the Pleasant Valley School District, formed on November 10, 1868, included, from left to right, Frank Davenport, John Mahan, and Jeremiah Sisson. The first-year classes were held in Hugo Carlson's granary, and six students attended.

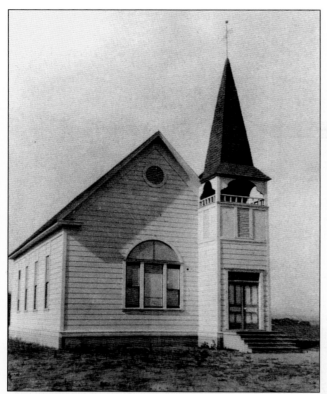

The Pleasant Valley Baptist Church was organized on June 12, 1869. School supervisors Davenport, Mahan, and Sisson were also instrumental in establishing the church that included 23 charter members. After years of holding services at the school or in the homes of various members, the first church was erected in 1891 on land given by Frank Davenport.

Baptismal immersion for new members was often held at the fishpond on the Thomas Rice Ranch or at the dam on Rancho Callegueas Creek. This ceremony records the baptism of Ida Willard by Rev. T. C. Douglas in April 1900.

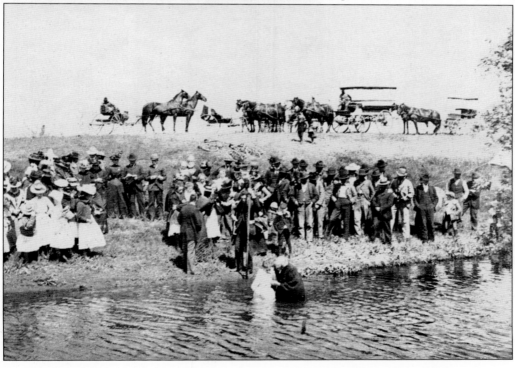

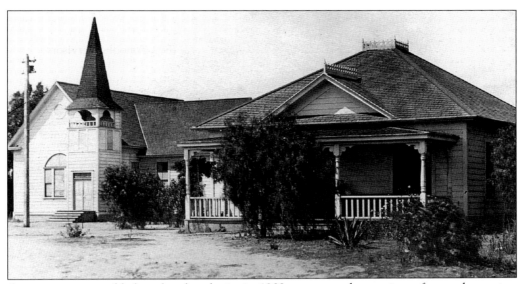

A parsonage was added to the church site in 1903 to ensure the services of a regular pastor. Previously Rev. C. C. Riley traveled from Fillmore and Rev. Thomas J. Wood served as the weekend pastor. When not available, Mrs. John Mahon would fill in for the absent pastor.

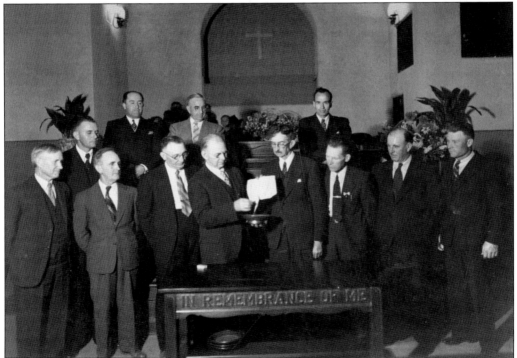

A "burning of the mortgage" ceremony took place on October 19, 1938. Participating in the ceremony were the church leaders of the Pleasant Valley Baptist Church. From left to right, they are (first row) John Fordge, Alvis Chunn, Earl Hamlin, W. P. Daily, Lorenzo Ward, Harrison Jellison, Ernest Marshall, and Elmer O'Bannon; (second row) Hillard Gerry, William Dawson, Dr. Deere, and Charles Sanders.

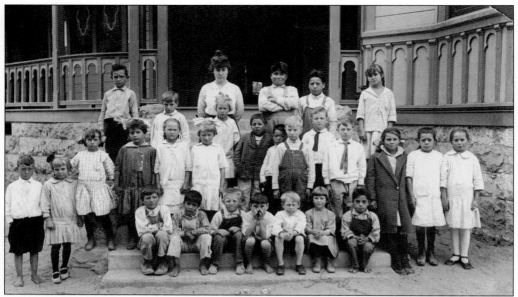

Mrs. Martin's class at the Pleasant Valley School is pictured here around 1900.

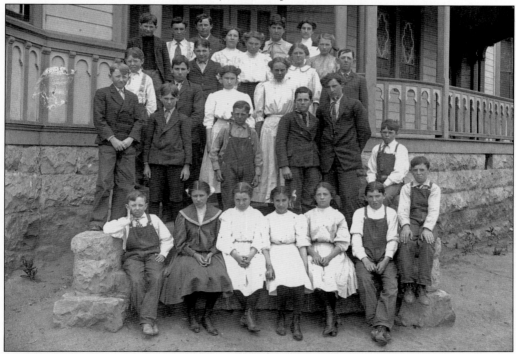

Students at the Pleasant Valley School are pictured here in April 1910; Helen Greene served as teacher. Among the faded names listed on the back of the photograph are George Flynn, Fred Lillie, Hubert Hughes, Joseph Lewis, Thomas Daily, Bennie Schmitz, Artie Sheppard, Clifford Tilton, John Finneran, Walter Flynn, Andy Lillie, Miles Mahan, Searles Mahan, James Mullinix, Finis Barns, Maggie Schmitz, Lillian Daily, Beatrice Spencer, Edna Daily, Hattie Mullinix, Verna Cawelti, and Mary LaValle.

This 1942 class photograph shows students from the Pleasant Valley School. Chata Ortiz, whose parents Meliton and Felicita worked for Adolfo Camarillo, is in the back row, second from the right.

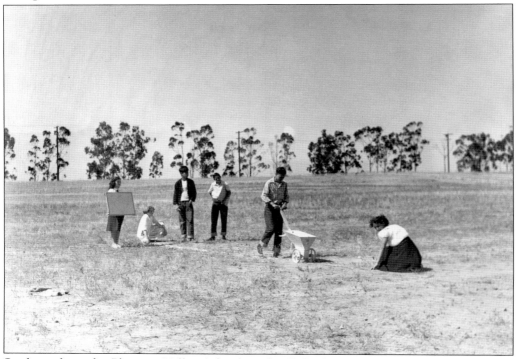

Students from the Pleasant Valley School mark off the baselines for a game of softball in the 1940s.

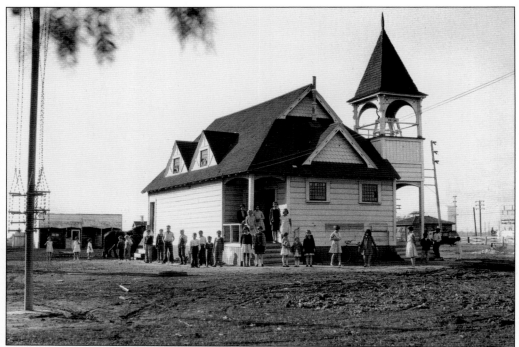

This is a rare photograph of the Springville area, *c.* 1900. In addition to the school building in the foreground, several of the original buildings are visible in the background.

During 1921–1922, an eight-room school was constructed. Five more classrooms were added in 1928.

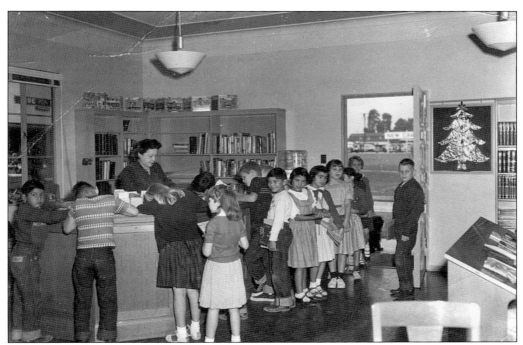

Adele Hernandez Flynn, above, served as Camarillo's librarian for 32 years, starting in 1934. At the time, the library offered 350 books and was located in the Cawelti Building. She also served as the city's first treasurer. Pictured here is the interior of the library at 2474 Ventura Boulevard.

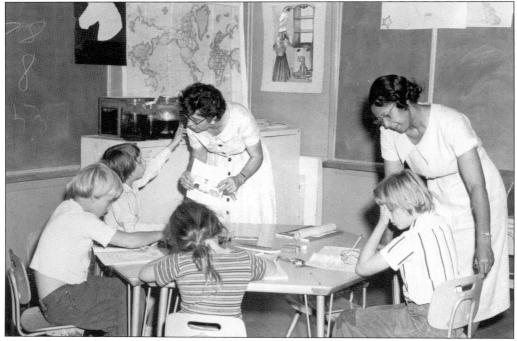

Camarillo State Hospital offered many services for its employees, including a school. The site also offered a movie theater and a gymnasium.

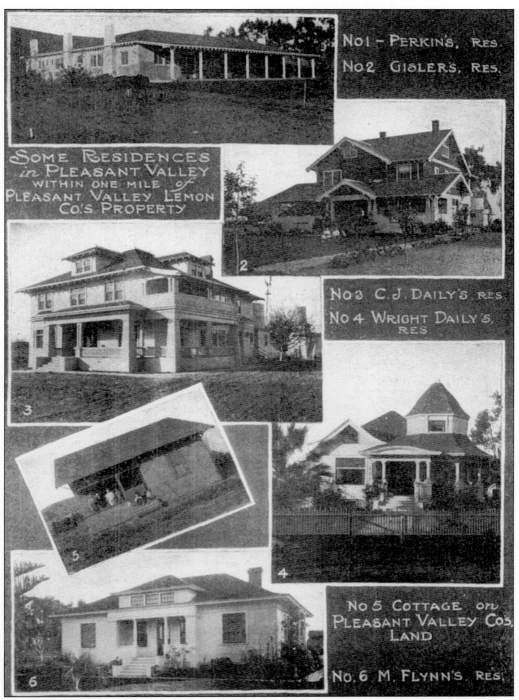

SOME RESIDENCES in PLEASANT VALLEY WITHIN ONE MILE of PLEASANT VALLEY LEMON CO'S PROPERTY

No1 – PERKIN'S RES.
No2 GISLER'S RES.
No3 C.J. DAILY'S RES.
No4 WRIGHT DAILY'S RES.
No5 COTTAGE on PLEASANT VALLEY CO'S LAND
No6 M. FLYNN'S RES.

In 1912, Albert F. Maulhardt conducted a series of experiments in the Camarillo Heights area, a 1,000-acre parcel owned by his cousin Louis Maulhardt and his wife, Theresa. Albert concluded that the sloping hillside was protected from frost and thus, favorable for planting.

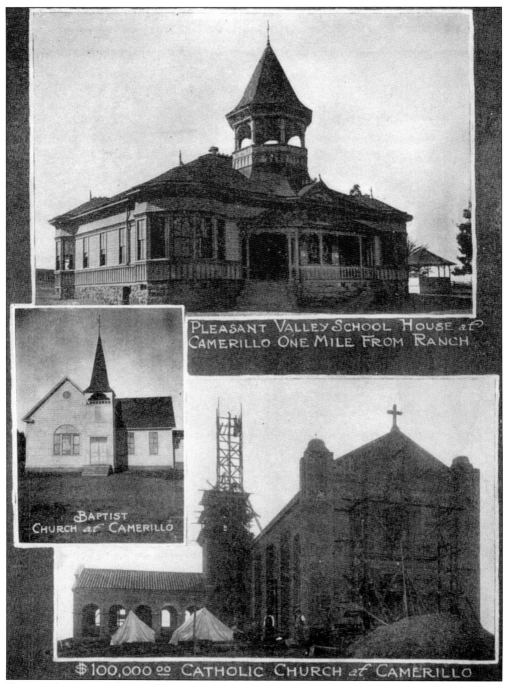

PLEASANT VALLEY SCHOOL HOUSE ℰ CAMERILLO ONE MILE FROM RANCH

BAPTIST CHURCH at CAMERILLO

$100,000 ℴℴ CATHOLIC CHURCH at CAMERILLO

Albert packaged a deal that included citrus trees from his cousin's ranch in Oxnard and water to be pumped from the Oxnard Plain. The *Oxnard Courier* provided front-page headline coverage on the deal: "Biggest Lemon Deal in California Made Here this Afternoon." However, the promised water to the heights could not be secured, and thus the sale to the Citrus Farm Company was denied. The top photograph shows the Pleasant Valley School House, *c.* 1895.

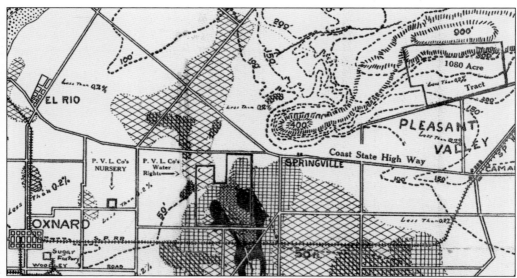

This map shows the outline acreage of the proposed citrus industry in relationship to the Maulhardt ranch in Oxnard, where the citrus nursery was located.

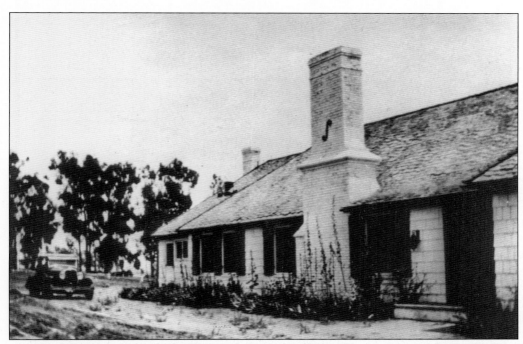

The Maulhardt family retained portions of the Camarillo Heights property until 1960. In 1926, Eddie Maulhardt built a home off present-day Charter Oak Street. Five years later, Eddie sold the house and acreage to Ray Thomas. Other portions of Camarillo Heights were sold to the Meztler brothers, developers who then sold the lots in 2-, 5-, 10-, and 20-acre increments.

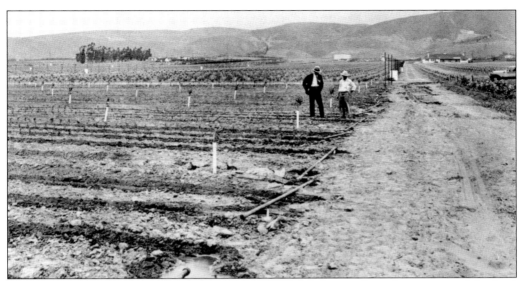

Ray Thomas purchased 150 acres of Camarillo Heights and soon planted a majority of the land in citrus groves. His daughter Helen and her husband, Clint Hutchins, moved onto the property. By 1972, the property was sold to Tanco Development Company, which built the Rancho Tomas homes on the north side of Las Posas Road. Clint and Helen Hutchins retained the two-and-a-half-acre site with the residence. The house was eventually demolished in 2005 to make way for more residences.

The row of eucalyptus trees near Charter Oak Street was planted as a windbreak shortly after Thomas purchased the property in 1931.

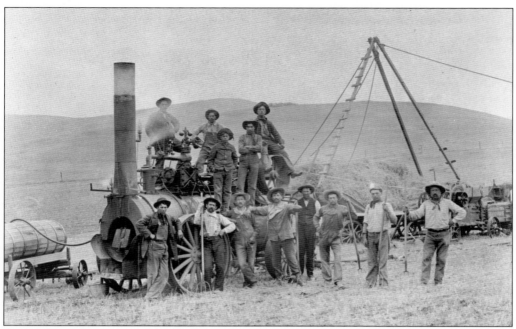

With a limited water supply, Louis Maulhardt (fourth from the left) and his crew worked the hillside of Camarillo Heights, pictured here around 1910, growing lima beans and hay.

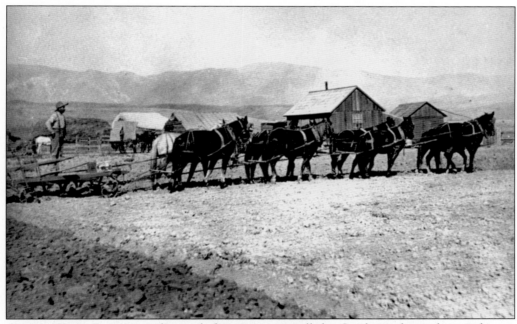

Antone "Tony" Baptiste used an eight-horse team to pull this Stockton plow at his ranch near Somis. Baptiste donated property on Bradley Road to celebrate his heritage. He had the Portuguese Crown Hall Building moved from the Perkins property to this location. The Portuguese families would gather there for three-day feasts filled with dancing, games, and ethnic foods.

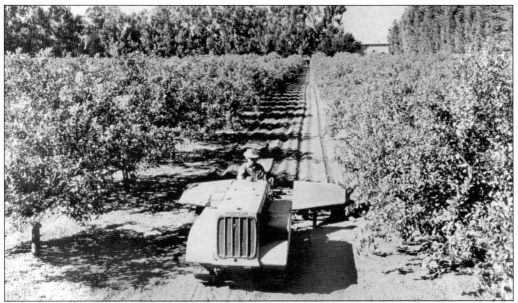

John Arneill's 365-acre property was located on the south side of Las Posas Road and east of current-day Arneill Road. He named his property "Raemere" in tribute to his wife, Elizabeth (Rae) Arneill. Born in Glasgow, Scotland, Arneill came to the Pleasant Valley in 1888. He died in 1894, when his horse bolted and the wagon ran him over. His brother and his son, John II, took over the ranching duties.

John Arneill II lost a portion of the ranch during the Great Depression, but he was able to later buy the property back. The ranch stretched all the way to Grand View Avenue on the south side.

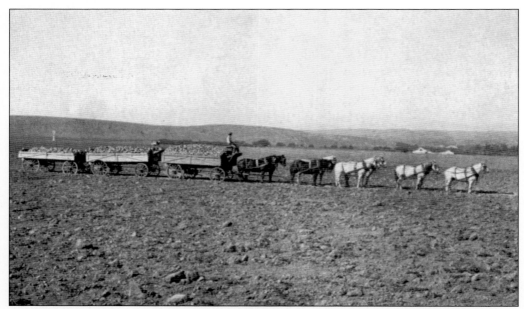

This photograph of E. W. Daily driving his beet wagon was used as a postcard. E. W. was one three Daily brothers, who, along with their father, Charles Wesley Daily, worked at the Patterson Ranch in Oxnard before buying a tract of land in Camarillo.

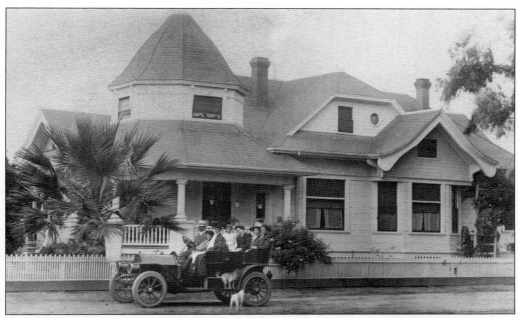

Eratus Wright Daily built a house near the corner of Daily Drive and Calle de la Roda, near the present-day site of a Carrow's restaurant. Daily's inspiration for the design came from the Walter Scott Chaffee house in Ventura. Daily's home was constructed in 1901–1902 and stood until 1970, giving way to a motel and a Bob's Big Boy Restaurant.

Wendell Daily invested in an 80-horsepower Fairbanks-Morse gasoline engine and a Layne and Bowler pump to drill a well 60 feet deep to produce a flow of 12 cubic feet of water. Comparably, his neighbors were only able to pump out four cubit feet of water at a time. To locate the proper site to dig his well, Daily hired a man out of Santa Paula named Kimball. Kimball used a green, Y-shaped pear branch that successfully led him to the prime spot.

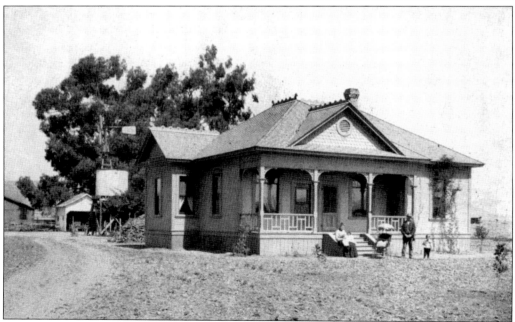

Wendell Daily's first home was located near Daily Drive and Lantana, near the Pierce Brother Griffin Mortuary. By 1940, Wendell replaced the original cottage with a larger, Spanish-style residence that is still standing.

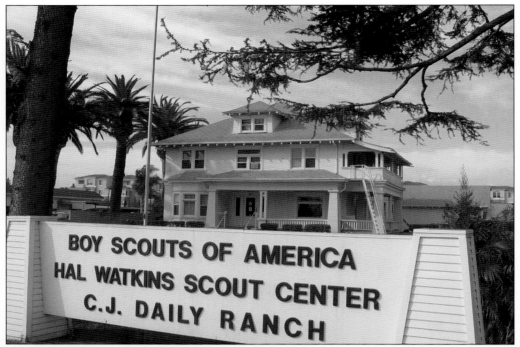

Charles Jay Daily built his Camarillo residence in 1910 at a cost of $7,000, or approximately $1.5 million by today's standards. Today the former residence, thanks to the generous donations from the Milton Daily family, serves as the headquarters for the Boys Scouts of America.

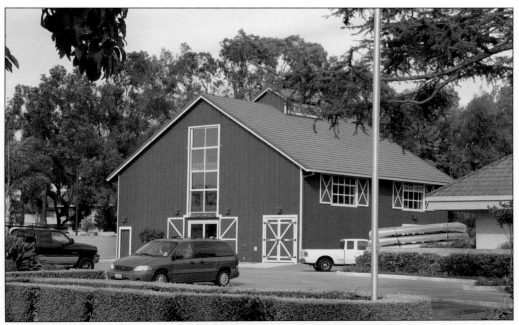

An updated, giant barn, similar to the original C. J. Daily barn, was built in 2002 to house scouting activities.

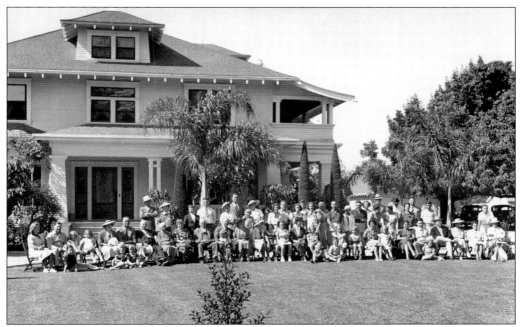

A Daily family reunion was held on the grounds of the C. J. Daily ranch in 1940. Daily's three-story home was built in 1910. Brother Wendell farmed to the east of C. J. Daily, and brother Erastus Wright Daily farmed on the west, off today's Daily Drive. The three brothers and their families numbered over 75 members.

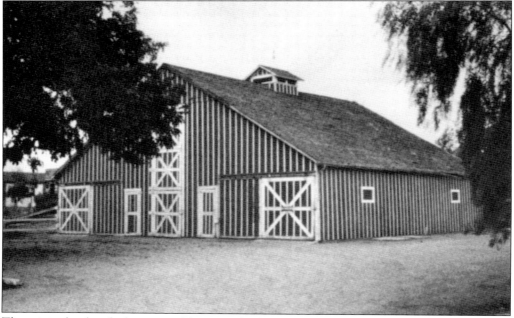

The original red and white striped barn was built around 1910.

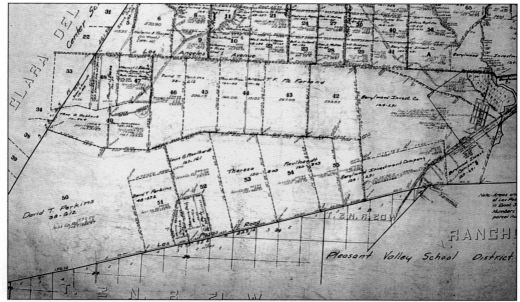

This *c.* 1910 map shows Camarillo Heights, north of Las Posas.

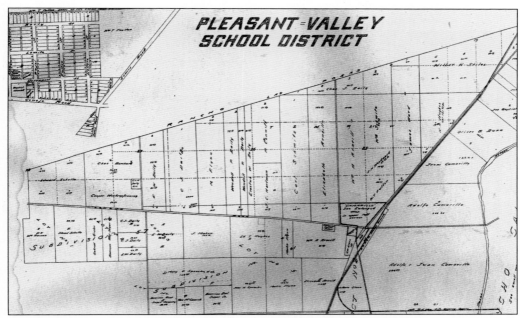

This map of the Pleasant Valley School District is taken from the "Alexander Atlas," which was published in 1912. The unclaimed triangular section between the surrounding ranchos was offered as government land and made available in the 1860s.

Three

SPRINGVILLE

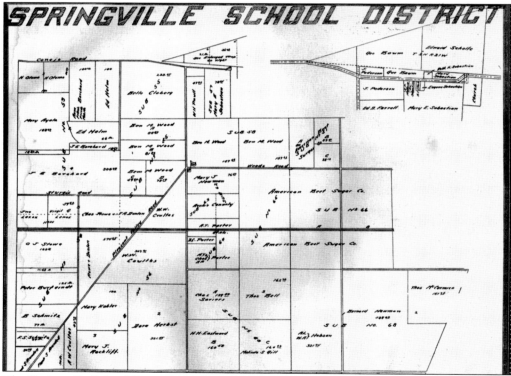

The Springville School District was formed out of the Pleasant Valley School District in 1887. The area of Springville preceded the town of Camarillo by 30 years. Located on a portion of John Sebastian's property and on the south side of Highway 101 and west of Central Avenue toward Wood Road, Springville offered two mercantile stores, a restaurant, feed stables, post office, school, church, tavern, and blacksmith shop. Among the farmers who lived in the area were George Baum, Christian Borchard, Peter Connelly, Albert and Alexander Coultas, Gabe Gisler, Charles and Lonnie Porter, William and John Riemann, John Sebastian, Ed Scholle, Bruce Swor, Hugh Tucker, and Albert Wucherpfenning.

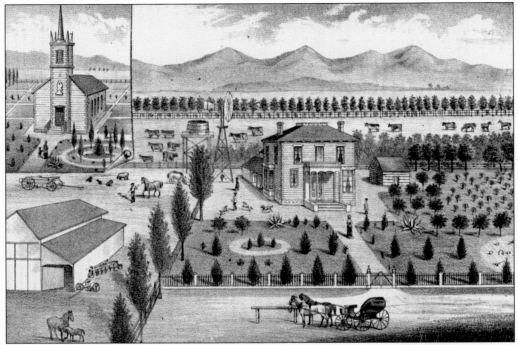

The home of Rev. William Otterbein Wood appeared in the 1883 Thompson and West publication on the history of Ventura County. Wood came to California via Ohio in 1868 and 10 years later organized the church in Springville.

The Wood residence was moved to make room for the flight path at the Camarillo Airport. The initial 5,000-foot runway was constructed in 1942 at the beginning of World War II, and another 8,000 feet was added in 1951 during the cold war era.

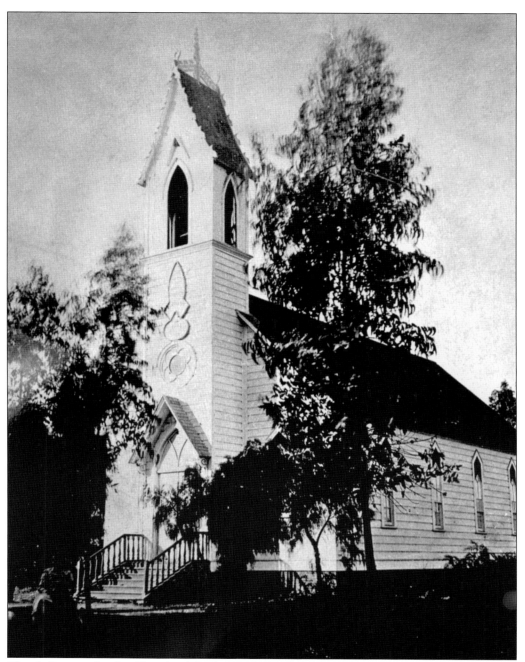

The dedication for the Church of the Little Flock of Regular Baptists took place on November 4, 1880. Reverend Wood is said to have locked Thomas Bard in the belfry until Bard promised financial assistance for the church. Bard agreed and kept his promise. (Courtesy of the Pleasant Valley Historical Society.)

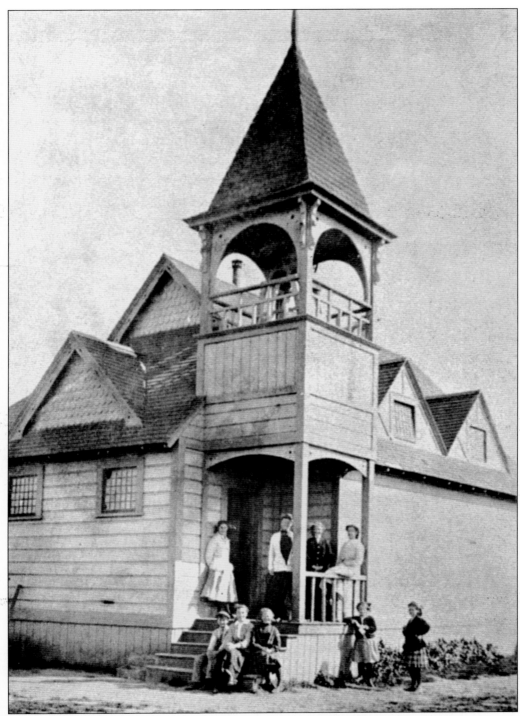

The Springville School was built in 1887, the same year the district was formed.

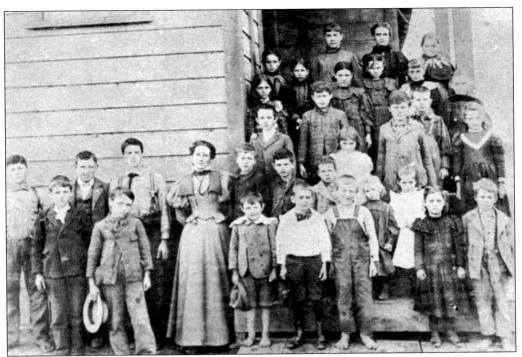

Zelda Rogers was the Springville School teacher at the time this photograph was taken in the 1890s. Among the families represented at this time were Baum, Coultas, Gill, McMartin, Methwin, Pederson, Saviers, and Wood.

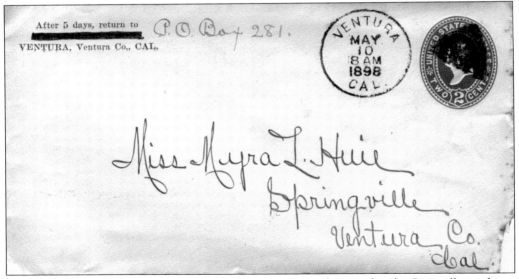

Myra L. Huie was the teacher at Springville School in 1898. She stayed at the Camarillo residence and began a letter-writing courtship with a young banker from Ventura, Charles McDonell. The letters started off very formally, but by the time the school year ended, the two were destined to be married, which they did within a few years. Their daughter Doris married Edwin Carty, a county supervisor, mayor of Oxnard, and world traveler.

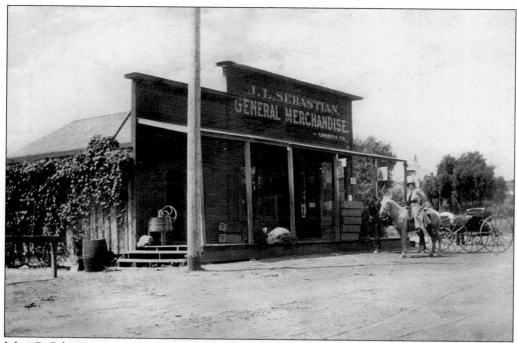

John C. Sebastian ran one of two mercantile stores in Springville. Sebastian's store was the first of many buildings to relocate to the new town center that became Camarillo.

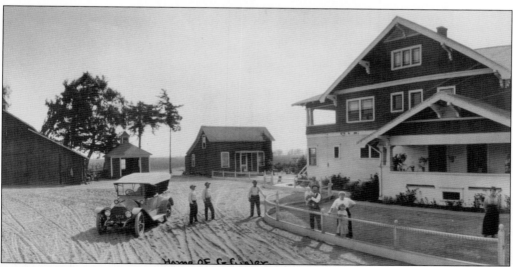

Gabe Gisler farmed several acres in Springville. Gabe's sister, Theresia, married another Springville/Camarillo farmer, Charles J Daily. Several of Gisler's brothers also took their turn farming in the Springville area, including Frank and Joseph. Samuel Gisler, a cousin, began farming the Camarillo Heights area in 1896 but sold to Johannes Borchard in 1903 and purchased land in Orange County.

Ed Scholle farmed several sections of land, including the Springville property, which was located almost directly across the road from the town of Springville.

The second Springville School, located near Pleasant Valley and Wood Roads, was built in 1930.

AUCTION

The undersigned will sell at Public Auction on the land of the American Beet Sugar Co. situated one mile east of

Springville, Saturday, Oct. 31, 1903

Commencing at 12 o'clock noon the following, to-wit:

One pair bay leaders, weight 1300 lbs.
One gray horse, weight 1400 lbs.
One black horse, weight 1200 lbs.
Three good set leather harness
Two saddles
One Stockton plow
One 6-foot King Chisel
Two 4-section harrows
One Killifer beet cultivator
Two walking beet plows, one truck wagon
One roller, two pulverizers

One pair gray horses, weight 1750 lbs.
One bay horse, weight 1300 lbs.
Two milch cows
Three set chain harness
One new Solid Comfort plow, two gang plow
One new 8-foot King chisel
One Cyclone
One Superior beet drill
One Umstead beet plow, either 1 or 2 rows
Two mowing machnies, two hay rakes
Two seed sowers, one walking plow

Forks, shovels, chains, stretchers, etc.

Terms of Sale: All sums under $10 cash; all sums over $10 either cash or one year's time on endorsed approved notes at 10 per cent.

THOS. B. CLARK, Auctioneer E. W. & W. P. DAILY

COURIER PRESS

E. W. and W. P. Daily held an auction in 1903 to sell various pieces of farming equipment. Ironically the town would also be "auctioned" off in the next several years with the completion of the rail line a few miles to the east.

Four

OLD TOWNE

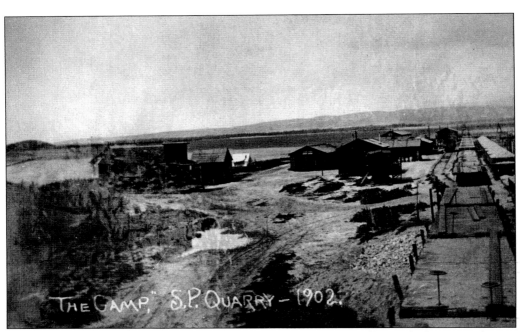

"THE CAMP," S.P. QUARRY – 1902.

This 1902 photograph shows the Southern Pacific camp at Camarillo. With the Oxnard sugar factory completed in 1898, a spur line was extended to Somis, prompting the development of a stop east of Springville. Sebastian's recently relocated mercantile store can be seen to the left of the rail line. Crushed rock from Old Boney Mountain was transported to Camarillo and used as the base for the railroad tracks.

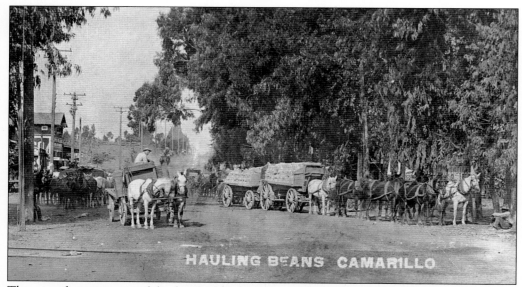

This view features some of the first buildings in Camarillo, looking west up Ventura Boulevard. The knoll on the left was owned by Juan E. Camarillo, and it became the site for the Mary Magdalene Chapel.

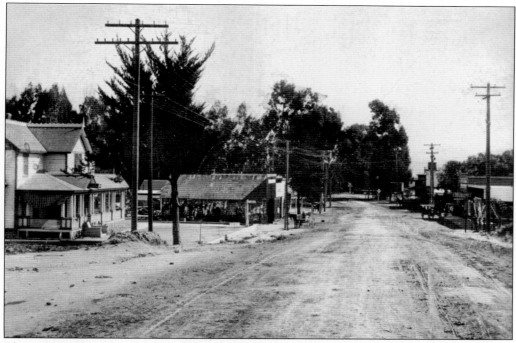

This c. 1909 photograph shows the opposite view of the above image, looking east toward the railroad tracks.

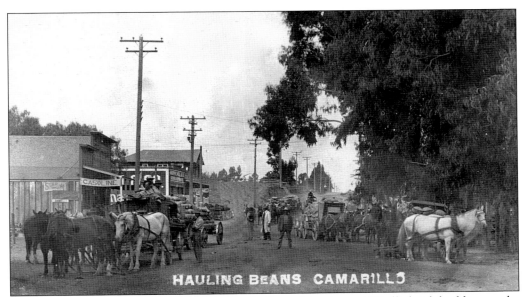

A similar view shows the Sebastian Mercantile Store, Murphy and Weill's brick building, and a restaurant.

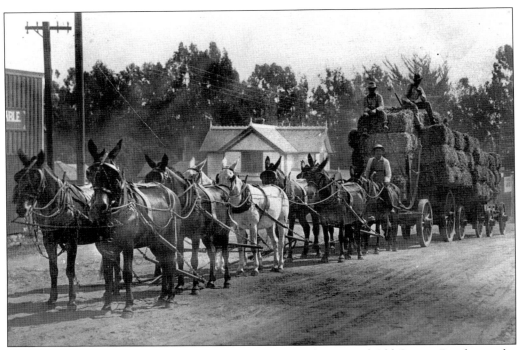

An eight-mule team pulling three wagons heads west on the original Old Conejo Road, past the Fulton Hotel.

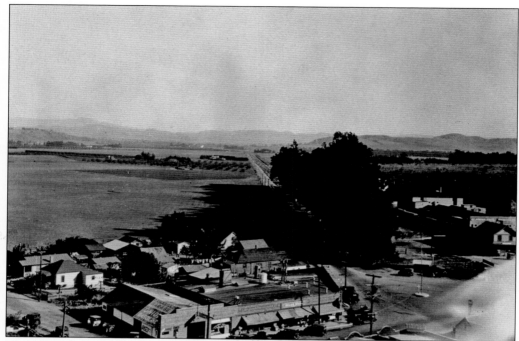

This blurred, yet telling aerial photograph shows the original location of the Camarillo Depot and the California Confectionary and Fruit Building. William C. Heck helped found the business around 1920, before retooling the building as the Ventura County Canning Company around 1952.

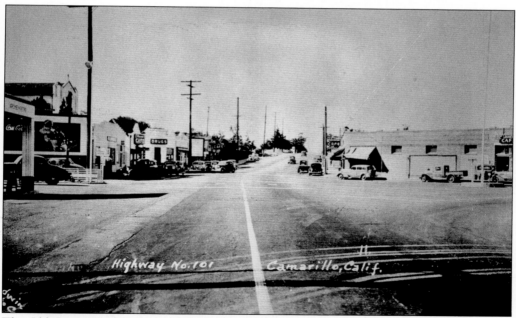

The Old Conejo Road was renamed Highway 101. This view shows the intersection of Somis Road, now Lewis Road, and Highway 101, now Ventura Boulevard, c. 1941.

The Cawelti Building is located at the northwest corner of Lewis Road and Ventura Boulevard. Frank Cornet's Meat Market, Leidel's Barbershop, and the Buckhorn Café and Saloon are among the businesses that have occupied the three buildings.

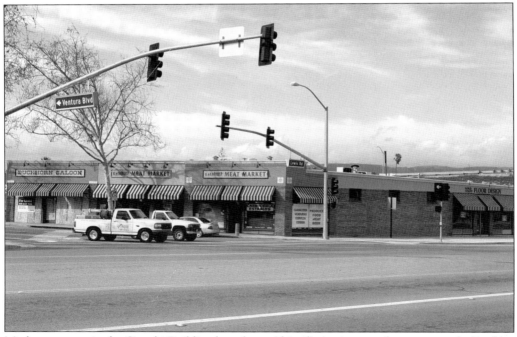

Modern tenants in the Cawelti Building have been Abigail's Antiques and, more recently, Establos Meat Market. The oldest business in Camarillo in its original location is also said to have the oldest liquor license in Ventura County—the Buckhorn Saloon. Sadly, as of this publication, it has been boarded up.

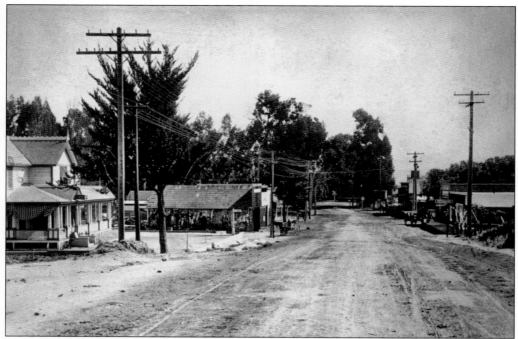

The Fulton Hotel joined the Willard Hotel/Home as one of the early buildings in Camarillo. The American Legion Hall sits atop the original site of the hotel, which burned down in a 1927 fire.

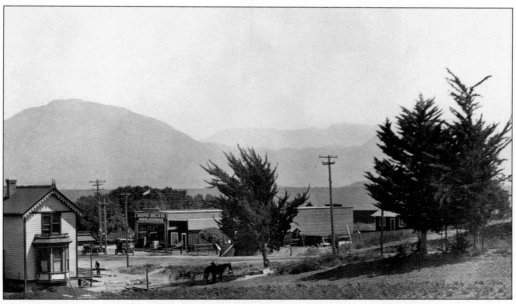

This *c.* 1909 view shows the Santa Monica Mountains in the background with the Fulton Hotel and the Murphy and Weill store in the foreground.

This northeast view shows the original location of the Camarillo Depot.

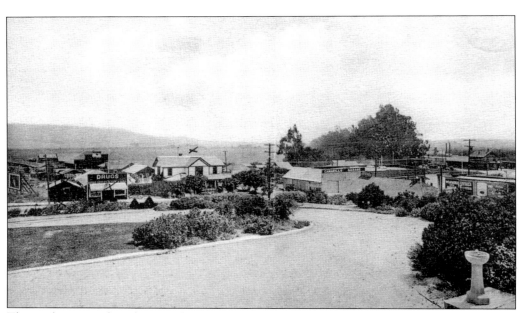

This early postcard, a photograph taken from the steps of the Mary Magdalene Chapel, shows the eucalyptus that once lined Somis Road.

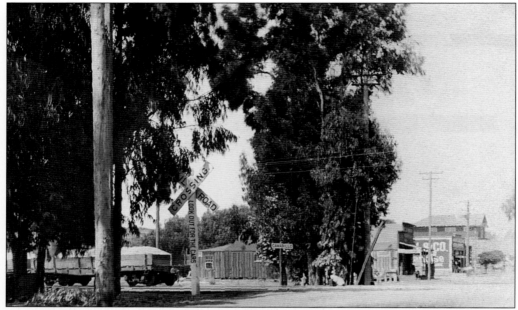

This is a later view of the Old Conejo Road looking west across the tracks.

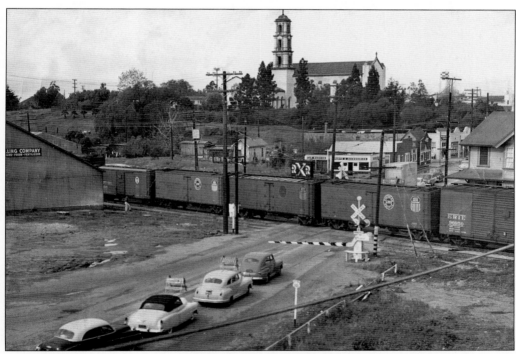

Mary Magdalene Chapel looms over downtown Camarillo.

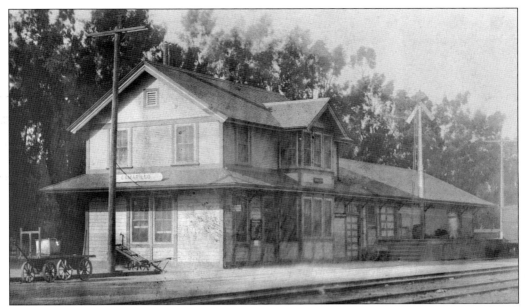

The proposed name for the Camarillo Depot was Calleguas. The name was rejected by the railroad, and Camarillo became a logical replacement. The depot opened in 1906 and closed 52 years later in 1958. The depot was moved in 1955 to the south side of the highway, where it stood vacant for the nearly a decade. In 1967, the depot was granted to the Pleasant Valley Historical Society. However, the "red tape" of legal right-of-ways stalled the transfer, and the window of time closed to move the depot. The historic building was demolished.

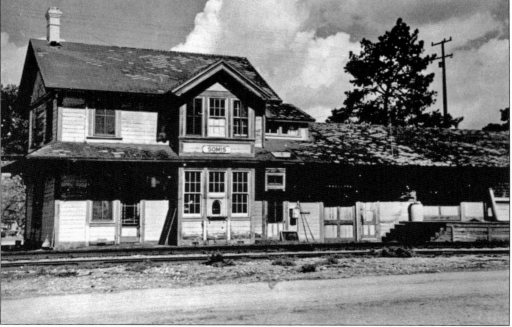

The Somis Depot opened and closed around the same time as the Camarillo Depot. Like the Camarillo building, the Somis Depot met the same demolition fate.

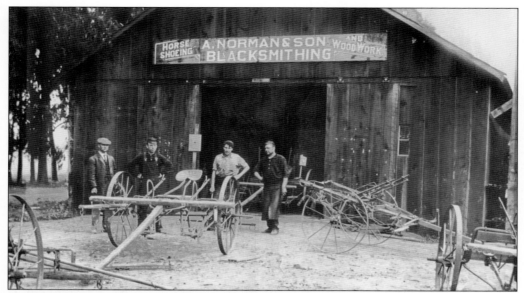

Ike Norman, second from the left, came from a long line of blacksmiths—three generations. In 1910, he opened up a blacksmith shop with his father, Arthur, at the foot of present-day Ventura Boulevard.

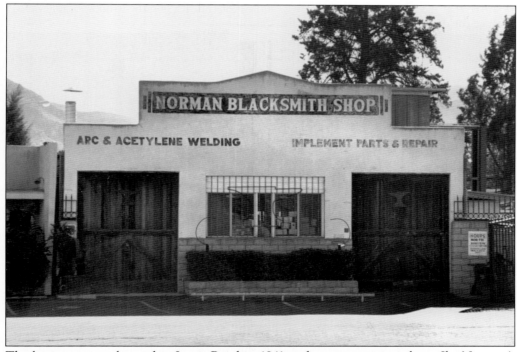

The business was relocated to Lewis Road in 1941 and, two generations later, Ike Norman's grandson, John E. Nukols, continues the business, branching out to include welding and light manufacturing.

The Flynn clan and friends "take five" outside the Myers-Adams store, *c.* 1910. George Flynn is pictured third from the right.

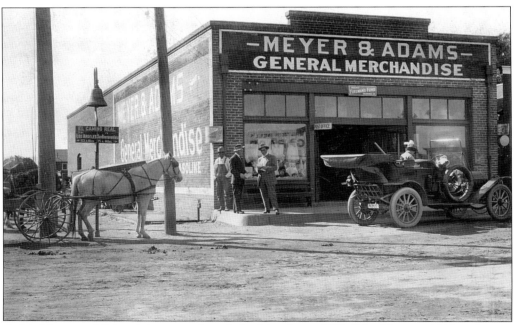

A. M. Meyer and John Adams purchased the Murphy and Weill building in 1910 and ran a general store. A few years later, Meyer bought out Adams and changed the name to Camarillo Mercantile Company. Israel Hernandez served as head clerk and bookkeeper and became part owner. By 1922, Max and Sam Riave had taken over the business.

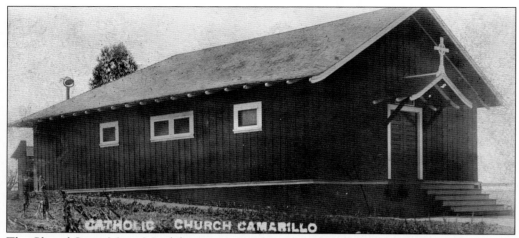

The Chapel Santa Maria Magdalene was a wooden structure built by Juan E. Camarillo in 1910. When the new chapel was constructed three years later, the wooden buildings were moved across the street and used as various stores.

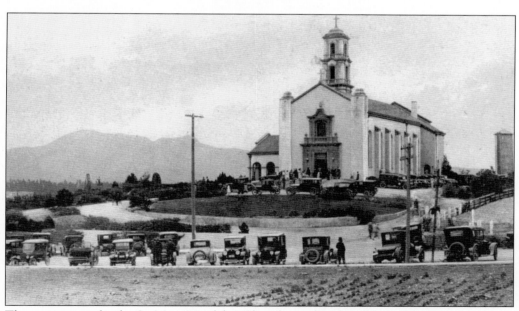

The cornerstone for the St. Mary Magdalen Chapel was placed on July 1, 1913. Noted architect Albert C. Martin designed the chapel according to Juan E Camarillo's inspiration for the mission style he observed while on his many travels.

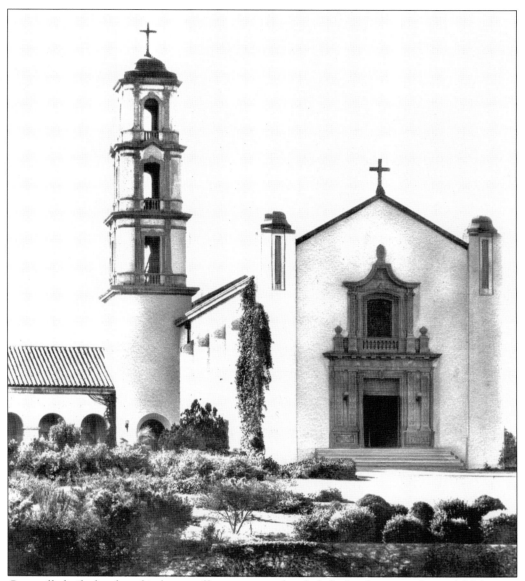

Camarillo built the chapel in honor of his parents and included a family crypt, a beautiful fountain, and 13 stained glass windows that Juan commissioned a German glassblower to design. Someone once said of the windows, "The thirteen magnificent stained glass windows of azure, crimson, green and gold tell a double story: the life of Christ and the world at war."

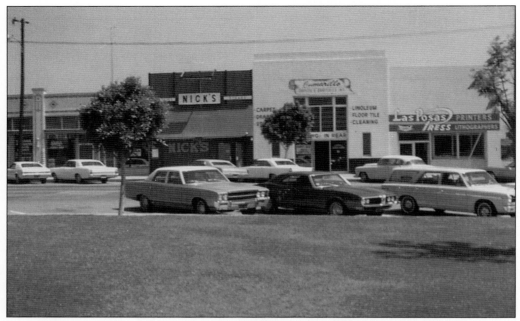

Joseph Lewis constructed this series of buildings between 1915 and 1916. The building housed a post office, shoe store, men's clothing store, and meat market. Nick's began as the Stein and Tally Department Store.

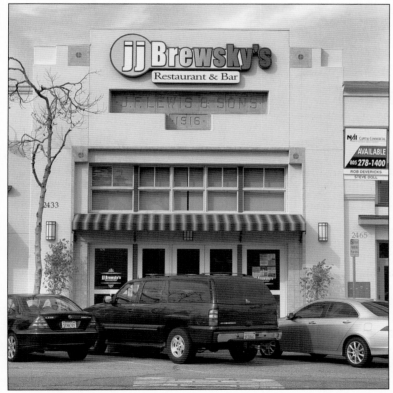

JJ Brewsky's Restaurant and Bar, 21st-century tenants, tastefully restored the original Lewis Building sign. This building has seen many incarnations, including a courthouse, Bank of America, ski shop, antique mall, and bookstore.

Before the Dutch Inn and Nick's, the building was used as the Valley Theater cinema. Santa Rosa rancher and movie star Joel McCrea, who starred in many westerns, would often bring his family to the theater.

The first in the series of Lewis buildings was originally a garage, constructed to house Joseph Lewis's Packard and roadster. It has been occupied in the 21st century by Camarillo Plumbing. Other businesses in the building included the Knob Hill Garage, an appliance and television store.

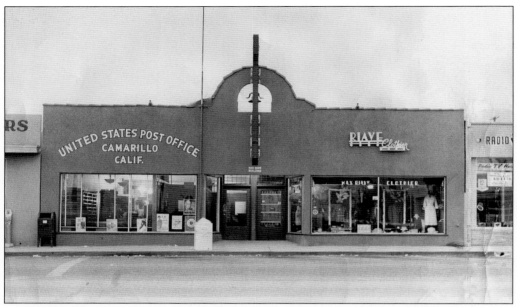

In 1946, Max Raive built this structure as two units. The eastern side was occupied for a short time by Richard Riave, who operated Camarillo Furniture and Appliance. In 1950, the post office moved in. The western unit was occupied by Max Raive Clothier.

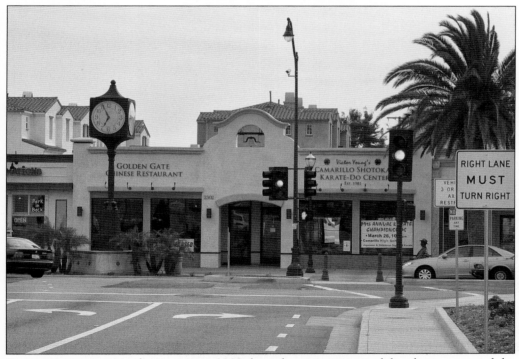

Downtown renovation, beginning in 2000, brought new or restored facades to many of the buildings, as well as a downtown clock and several life-size statues, including the seated Joel McCrea in front of the Karate-Do Center.

In 1980, the Evangelical Free Church of Camarillo purchased the former Pleasant Valley Baptist Church.

Henson's Music started in Oxnard in the late 1940s and expanded to Camarillo in 1963. Located on Ventura Boulevard, the store has survived road closures and remodeling along the boulevard to keep its doors open over 40 years.

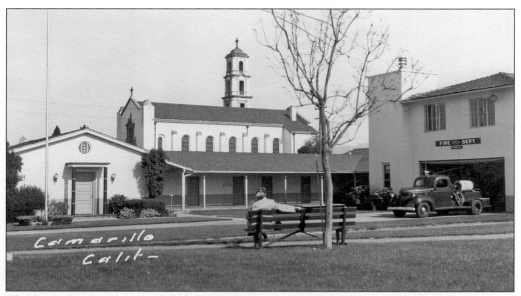

The fire station buildings and the adjacent library were built in 1941. Gene Putnam was hired as Camarillo's first full-time fire chief and served a 22-year term.

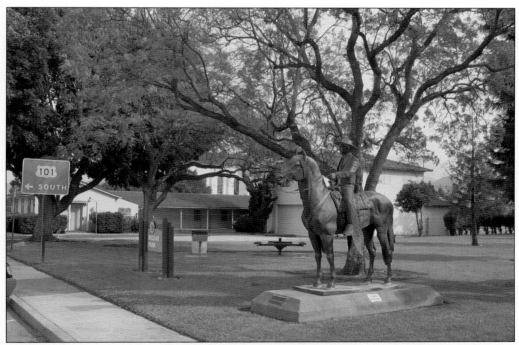

Though the fate of the vacant, historic fire station has not been determined as of publication, the legacy of Adolfo Camarillo is preserved with this statue of his likeness on a horse, placed between the two buildings at Ventura Boulevard and Dizdar Park. His brother, Juan, donated $15,000 of his will for the construction of the buildings.

Five

SOMIS

Early references to Somis called it "the Adobes." One of the adobes was occupied by the Rice and Bell families, pictured here. Peter Rice purchased 1,150 acres of Rancho Las Posas in 1871. His daughter Rebecca married Robert Bell, who formed a partnership with Rice. They farmed a total of 3,000 acres in the area. Their long presence in the area led to the naming of Rice and Bell Streets in Somis. (Courtesy Betty DeSerpa Embry.)

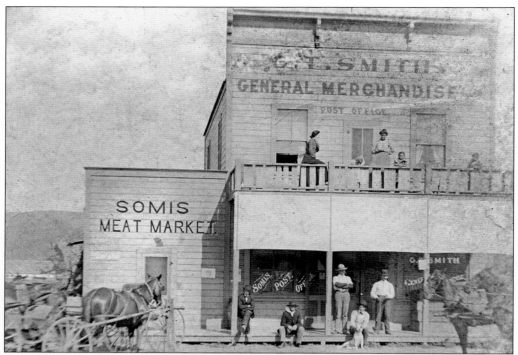

Located at the corner of Somis Road and Rice Street, this two-story grocery store was built in 1899 by Tom Smith. He later sold it to Stewart and Sebastian. John Gale was the next owner, followed by Bob Compos, who used the building as a pool hall and barbershop. The building was torn down in 1915.

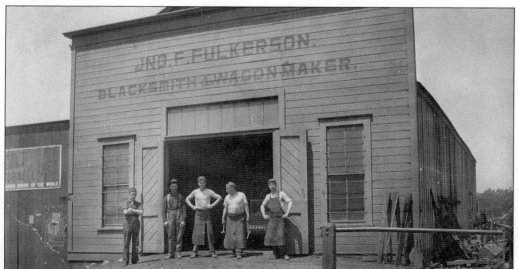

The first business in the town of Somis was the James F. Fulkerson blacksmith shop in 1892, located on the southwest corner of Somis Road and Rice Street. Fulkerson's brother Jonathan joined him in business and, in 1900, took over the shop when James opened a blacksmith shop in Oxnard. Taking time out for a quick photograph, from left to right, are Cecil Stockton, Jonathan Fulkerson, Jim Johnson, Jim Anderson, and Charles Kelly.

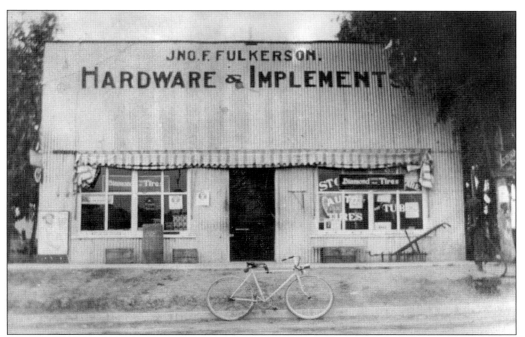

In 1912, Jonathan Fulkerson purchased the lot on the northwest corner of Somis Road and Rice Street and opened the Fulkerson Hardware Store, which is nearing its 100th year of operation with three generations of Fulkersons at the helm—Jonathan, his son Jack, and Jack's son Robert.

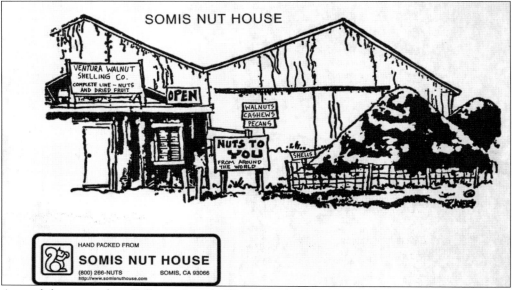

Around the corner from Fulkerson's and off Los Angeles Avenue is anther Somis institution, the Somis Nut House. The Nut House fronts a nut processing plant that opened in 1959. The business was started by Stephen Resnik and his parents and has expanded to include four generations of Resniks. The Nut House is a reminder of the change in agriculture in the last half century, from walnuts and citrus to berries and nuts. Fortunately for the community, the Nut House survives. This Nut House pen and ink drawing is by local artist Ray Ayers.

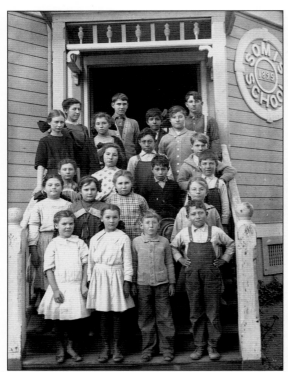

The Somis School, built in 1895, was located at the corner of Somis Road and Bell Street. This photograph, taken during the 1909–1910 school year, includes students from grades one to eight.

The Somis School served the students of Somis at this site until 1924, when the Thursday Club, a local women's organization, took over the building and a new school was erected on North Street.

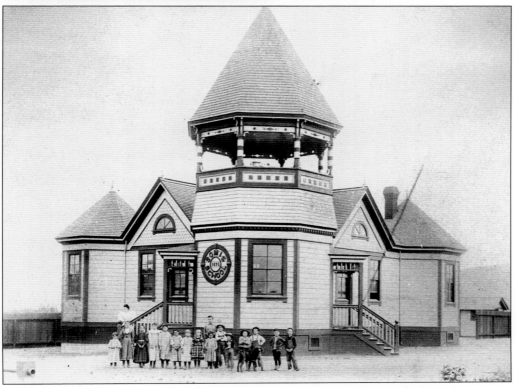

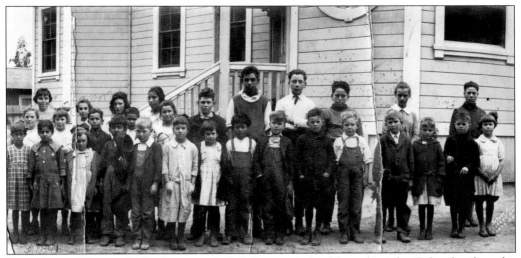

Future Somis/Pleasant Valley historian Jack Fulkerson is third from the right. Other families who attended the Somis School included Baptista, Barnett, Beasley, Bell, Bradley, Brown, Cardozo, Cawelti, Cline, Eggleston, Farrar, Fox, Gatchell, Goodyear, Guthrie, Hughes, Johnson, Jones, Machado, Mahen, Nelson, Palin, Pitts, Sauers, Smith, Snyder, Soares, Stuart, Unruh, Woods, and Wooley.

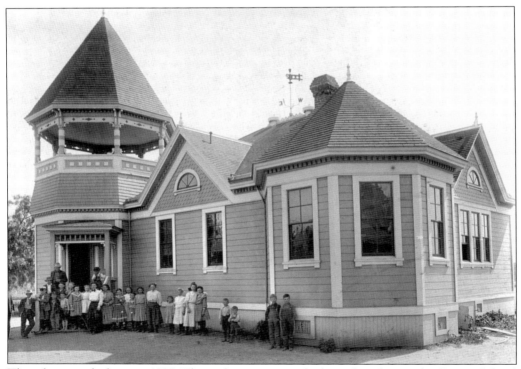

This photograph dates to 1907. The architecture was duplicated at the nearby Center School and the Mesa School.

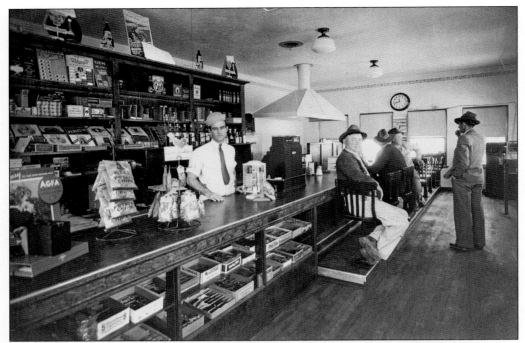

The interior of the Somis Café is depicted in this photograph. Seated in the middle is local farmer Jim Gill, who was born in County Longford, Ireland, in 1880. He traveled to the United States, settling in the Somis area with his family at the age of three. He later farmed here.

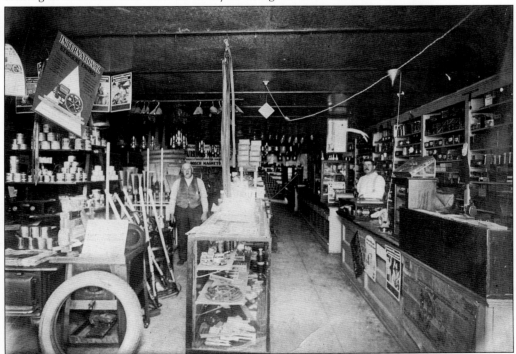

The interior of Fulkerson's Hardware is pictured here. Jonathan Fulkerson is seen on the right.

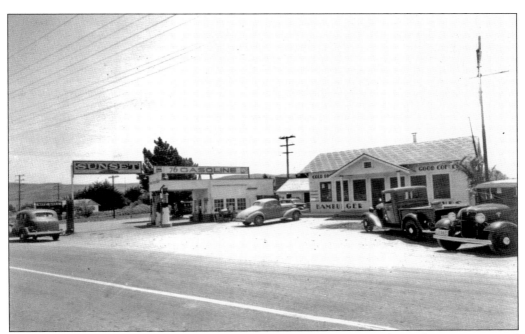

A view of the corner of Somis Road and Los Angeles Avenue, *c.* 1940, shows the gas station and the Somis Café.

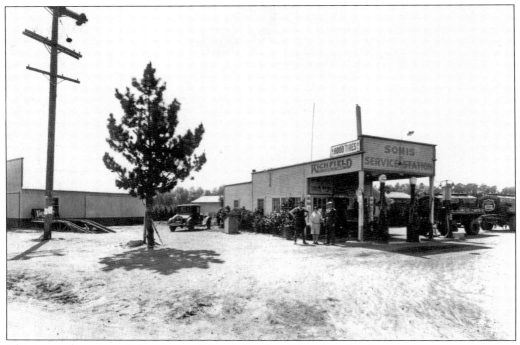

This is another view of the corner of Somis Road and Los Angeles Avenue.

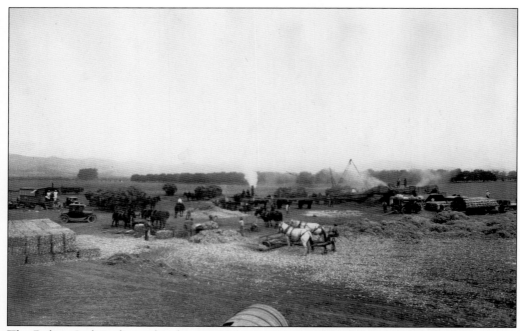

The Robert Lefever bean-threshing outfit is pictured near Somis, *c.* 1920. Robert Lefever Sr. served as a county supervisor, and both Sr. and Jr. farmed lima beans.

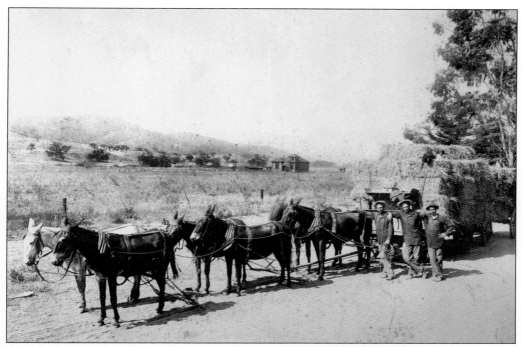

A six-mule team, two-wagon rig is pictured near Somis.

Six

FAMILIES, FRIENDS, AND NEIGHBORS

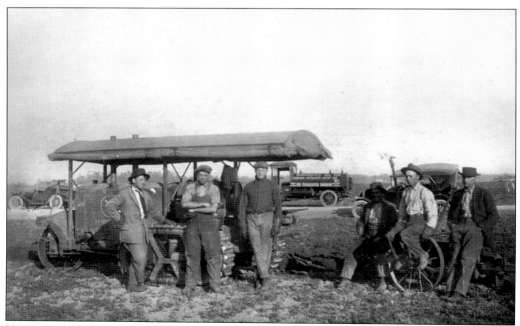

Henry Borchard purchased this Yuba tractor in 1914 for $3,500. The background shows a "gas truck" that would drive out to the fields to fill up the tractors.

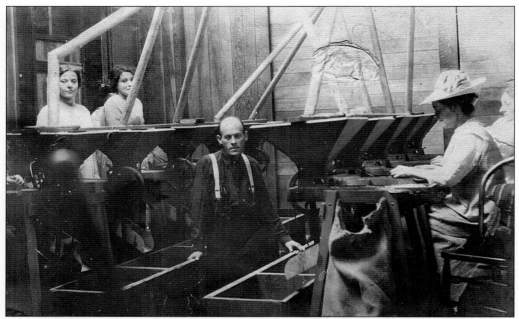

During the 1940s, workers are sorting walnuts at the warehouse. Seated second from the left is Adele Hernandez Flynn. During the 1930s, the average run on walnuts was 18,000 tons.

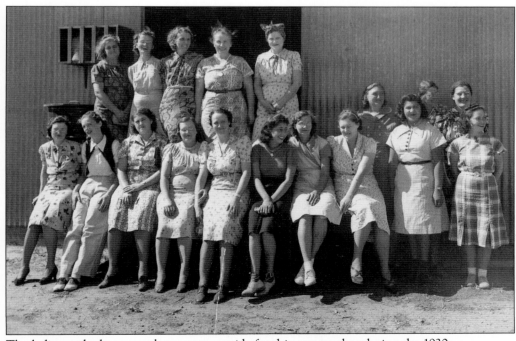

The ladies at the bean warehouse step outside for this camera shot during the 1930s.

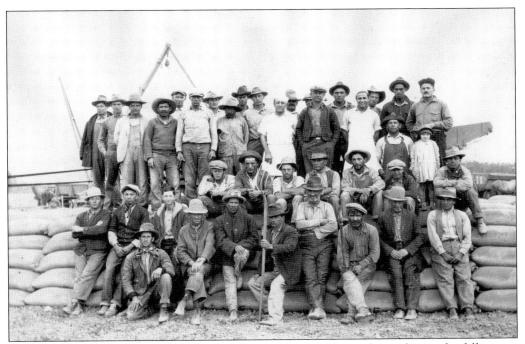

The crew from Robert Lefever's bean-threshing outfit worked long hours during the fall season to get the beans harvested and sacked.

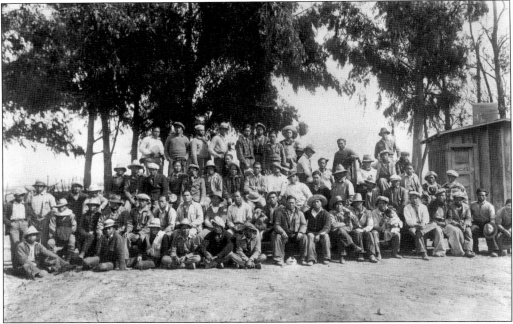

This group photograph shows Filipino workers at the Arneill ranch. The labor force in the area fluctuated according to the economic times and agricultural direction. With the change from dry farming lima beans to citrus and walnut groves, a large workforce was only necessary during the harvesting season.

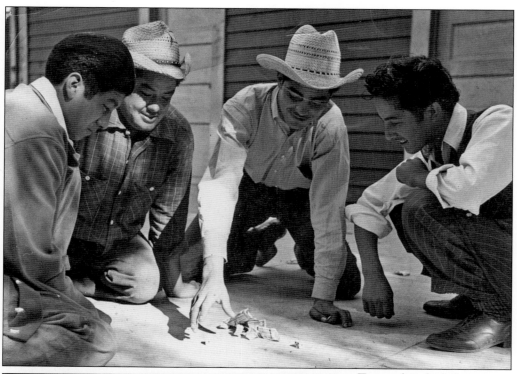

Trying their luck during some down time at the Camarillo Ranch, from left to right, are Tony Orozco, Nacho Ceja, Meliton Ortiz, and Julian Rivera.

An expanded crew at the Adolfo Camarillo Ranch in the 1940s included Meliton Ortiz, second from left.

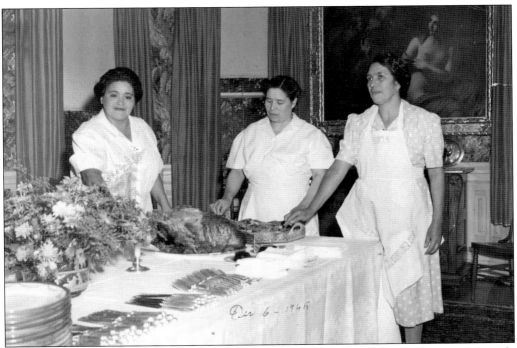

Helping inside the Adolfo Camarillo home in December 1945, from left to right, were Manuela Ortiz, Natividad Servin, and Francisca Ortiz.

Israel Roman Hernandez began attending Oxnard High School with 25 classmates. By 1908, he was one of six to graduate. Among his studies were physics, botany, manual training, stenography, and bookkeeping. Pictured, from left to right, are (top row) Harry Gabbert, Ruby Horsley, and Fargo Rose; (bottom row) Israel Hernandez, Alleene Walker, and Walter Dimmick.

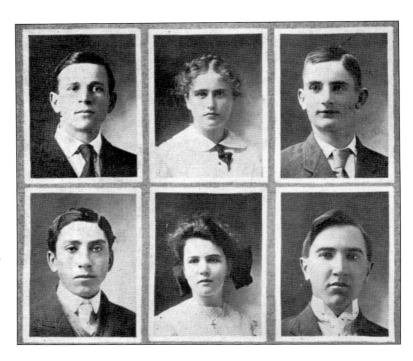

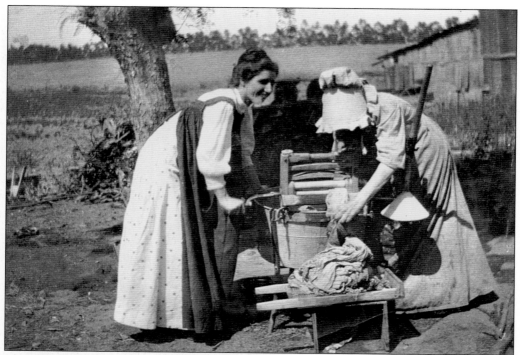

Blanche Coultas and Marietta Barnett Hughes look like they have come up with a realistic reenactment of how the pioneer women washed their clothes. However, this photograph is from the beginning of the 20th century, and this was how it was done.

Edna Daily is depicted at the Charles J. Daily Ranch, c. 1910. Edna was the second daughter of Charles Ray Daily and Theresia Gisler Daily.

This is a portrait
of Florence Brown
Dawson, daughter of
Laura Willard and
Wallace Weston
Brown and great-
granddaughter of
John Y. Saviers.
Florence became the
family historian and
contributed greatly
to the preservation of
the family's history.

This is the wedding photograph of Fannie Hughes and Jonathan Fulkerson. They raised three children—Birdie, who married William Culbert; Inez, who married Hugh Conway, and Jonathan (Jack) Fulkerson, who married Barbara Meyer.

Alfred John Petit and Rosa Avelina Camarillo were the first couple to marry in the St. Mary Magdalene Chapel in 1914. The couple was granted a gift of 143 acres on the south side of Highway 101 from Rosa's father, Adolfo Camarillo. The ranch was enlarged to 900 acres after the death of Adolfo in 1958.

In 1946, Jack and Barbara Fulkerson spent their wedding night in Las Vegas. The Fulkersons became instrumental in forming and maintaining the Pleasant Valley Historical Society. Jack served as the charter president in 1965; Barbara assumed the secretarial duties for several terms. Upon Jack's passing, the Pleasant Valley Historical Society dedicated the research library in his honor, and it is known today as the Jack Fulkerson Library.

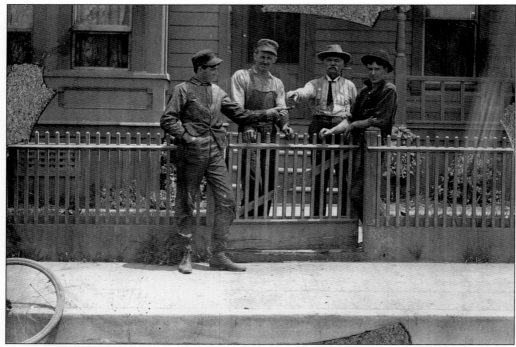

This photograph, from the Flynn family archives, was taken around 1910 near downtown Camarillo.

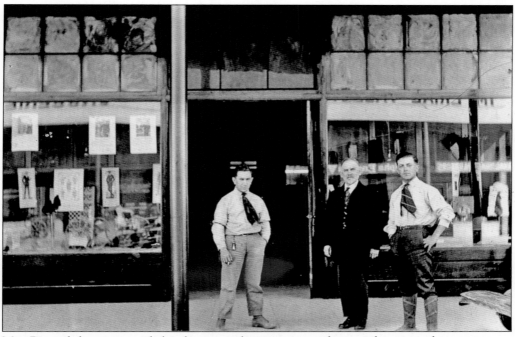

Max Riave, left, steps outside his downtown business to see if anyone has spotted a customer.

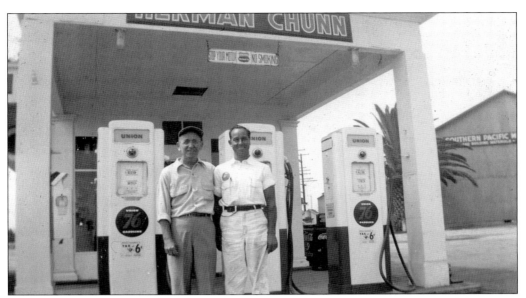

On the east side of Lewis Road was a Union 76 Station. Among the men who managed the station over the years were Owen Marshall, Al Ward, Joe Hernandez, the Etchechoury brothers, Gibb Sawtelle, and Herman Chunn, pictured on the right.

At a luncheon at Florence Obiols Maulhardt's residence in Los Posas Estates, showing off the latest fashions, from left to right, are Carmen Camarillo Jones, Florence "Flo" Obiols Maulhardt, and Bea Beardsley Hudson.

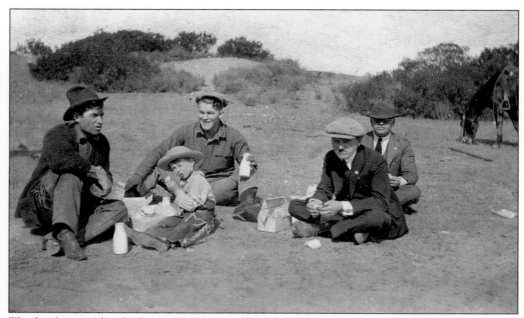

The landscape of early Camarillo has served as the backdrop for several movies and television shows. Here Will Rogers, left, and Jackie Coogan, the young boy, relax between takes.

Actor Leo Carrillo, middle, and Juan Camarillo, right, share a laugh on the steps of Juan's home around 1936. Carrillo was also from a pioneering Californio family. He stared in 93 movies and was best known as Pancho, the sidekick on the series *The Cisco Kid*. (Courtesy Robert Hernandez.)

Capt. Steve Flynn gives movie star Shirley Temple a lift. Flynn worked for the California Highway Patrol. Flynn eventually became the captain in charge of the San Francisco Bay Bridge.

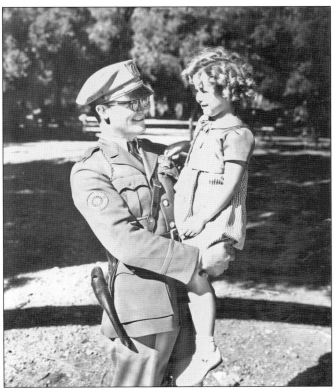

The property for the Camarillo Boys and Girls Club was purchased through a donation from Manuel Silveria. Hollywood actor and Santa Rosa rancher Joel McCrea, left, also made a generous donation for the construction of the building.

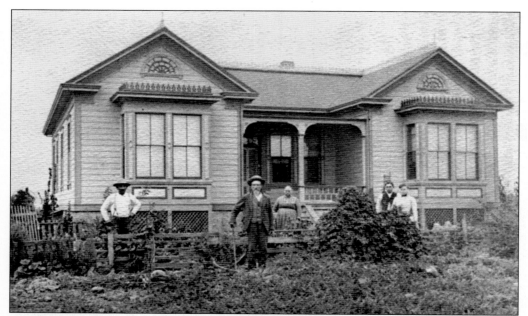

The John Cawelti family poses in front of their home in 1890. John Cawelti was from Wurttemberg, Germany. He owned 135 acres in the Springville area and leased another 1,000 acres in Conejo, growing 800 of those in wheat and 30 in corn. He also raised 500 hogs.

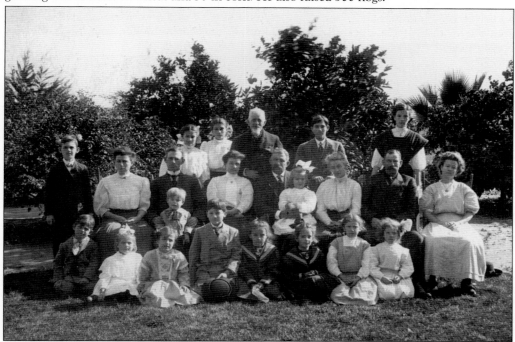

The Daily family reunion is pictured here in 1908. From left to right are (first row) Roscoe, Emma, Emogene, Milton, Mayre, Martha, Bernice, and Gladys; (second row) Paul, Lenora Deutsch Daily, Wendell, Frank, Theresia Gisler Daily, Charles Jay, Margaret, Etta, Erastus Wright, and Nellie; (third row) Edna, Lillian, Charles Wesley, Thomas, and Ruth.

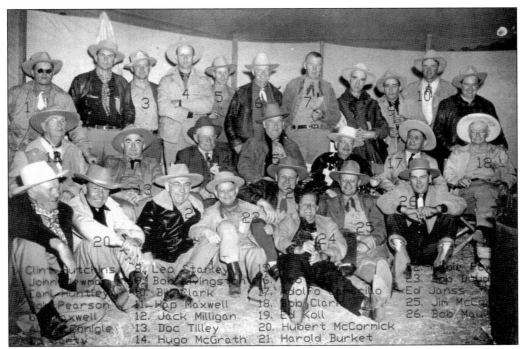

Clint [illegible] | 8. Leo Stanley | 15. [illegible] | [illegible] | 23. [illegible]
John [illegible] | 9. Bob [illegible]ingston | 16. [illegible] | Ed Janss |
Earl Huntley | 10. Bill Clark | 17. Adolfo [illegible]illo | 25. Jim McCo[illegible] |
[illegible] Pearson | 11. Hap Maxwell | 18. Bob Clark | 26. Bob Mau[illegible]
[illegible]axwell | 12. Jack Milligan | 19. Ed Koll |
[illegible]onigle | 13. Doc Tilley | 20. Hubert McCormick |
[illegible]ty | 14. Hugo McGrath | 21. Harold Burket |

A who's who of Ventura County's early farming families represented in this 1940s group photograph of Campo Adolfo ("Adolfo Camarillo's children") took part in an annual horse ride at Rancho Visitadores. The ride started in 1930, and two years later, Adolfo Camarillo joined the annual ritual.

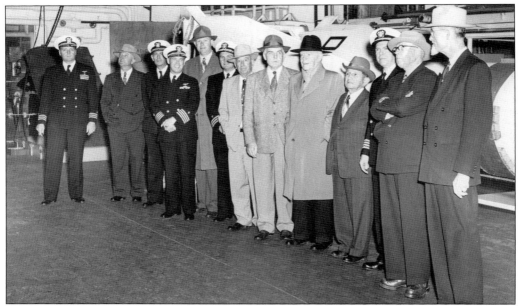

Local dignitaries inspect the latest naval ship to dock at the Hueneme Harbor. The first civilian from the left is Matt Borchard. The first four civilians on the right are Robert Clark, Adolfo Camarillo, Rudolph Beck, and Judge David Flynn.

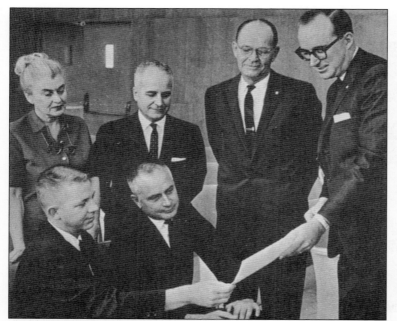

The Camarillo City Council first convened here in 1964 and included, from left to right, (first row) Stanley Daily and Ned Chatfield; (second row) Tweedy Camarillo Rouce, Mayor Earl Joseph, and Guy Turner, with Ventura county supervisor John Montgomery on the right end. The vote for incorporation was 1,900 in favor and 353 against. The original boundary for the city encompassed 5.4 acres.

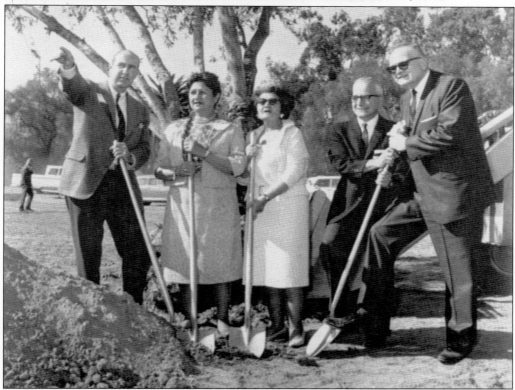

Great Lakes Properties held a groundbreaking and invited the Camarillo sisters. Pictured here, from left to right, are unidentified, Carmen Camarillo Jones, Rose Camarillo Petit, Earl Joseph, and Loring Marlett.

Eric Daily takes the reins as president of the Pleasant Valley Historical Society at the 1999 Don and Doña Barbecue. This year's ceremony branched out to another Camarillo family property, located at the reservoir along Santa Rosa Road. Among the year's recipients were longtime community volunteer Ken Anderson, Donna Bailey, Gail Beltrano, Helen Clausing, William "Rod" Franz, Ira Grooms, Gloria Jones, Doris Lovell, Keith Noren, Frank and Betty Diedrich Staben, Becky Thayer, and George Thayer.

Two longtime community volunteers, Stan and Liz Daily, happily count the receipts from the Pleasant Valley Historical Society's annual barbecue.

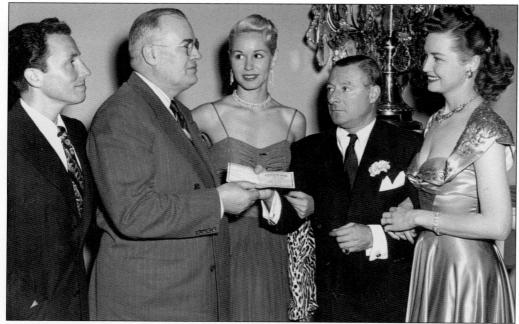

Franklin H. Garrett, second from left, welcomes comedian/actor George Jessel at a fund-raiser at the Camarillo State Hospital. Garrett began working at the hospital in 1937. Within a year, he was promoted to vice superintendent. After serving his country during World War II, Garrett returned to his home state. After a brief stint at a Norfolk, California, facility, he returned to Camarillo to take the position of superintendent for the next 14 years.

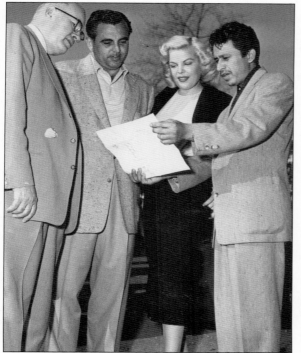

Franklin H. Garrett, left, looks over some documents with actor Pedro Gonzalez-Gonzalez at the Camarillo State Hospital. Pedro was discovered in 1953 when he showed up as a contestant on the Groucho Marx television show *You Bet Your Life*. Actor John Wayne saw the show and immediately signed Pedro to his production company. Pedro went on the star in several Wayne movies including *Rio Bravo*, *McLintock!*, and *Chisum* as well as many other movies and television shows.

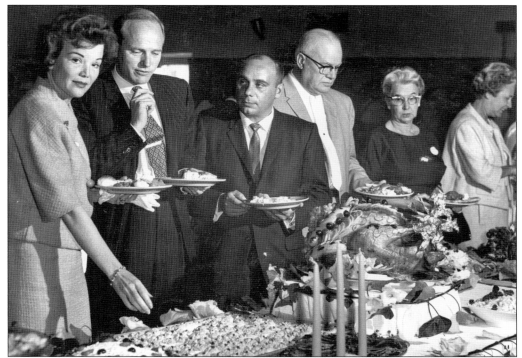

Actress Nanette Fabray, left, whose career spans 70 years, was in the forefront of championing the rights for handicapped people. Here she attends a luncheon in support of the efforts of the staff at Camarillo State Hospital. Fabray credited the hospital for helping her through her nervous breakdown.

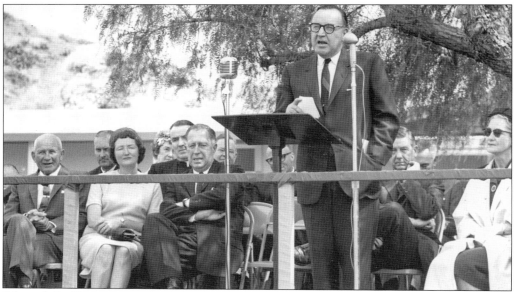

Edmund G. "Pat" Brown, Democratic governor of California from 1959 to 1967, addresses the crowd at Camarillo State Hospital. Second from the left is Jane Tolmach, a longtime community activist and one-time Oxnard mayor.

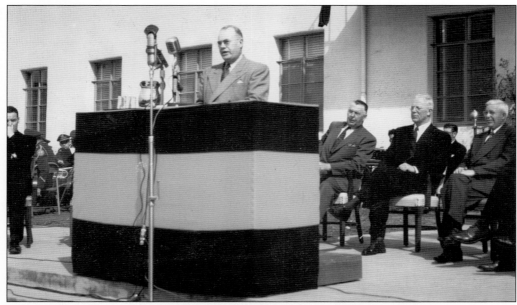

Taking the podium for the dedication of the Receiving Treatment Unit at Camarillo State Hospital in February 1952 is Franklin H. Garrett. Seated behind Garrett, from left to right, are county supervisor Edwin Cary, Gov. Earl Warren, and Dr. Frank Tallman. The next year, Earl Warren was appointed to the United States Supreme Court by Pres. Dwight D. Eisenhower. One of Warren's first big cases was the historic Brown *v.* Board of Education. Warren wrote the unanimous decision ending segregation in the nation's schools.

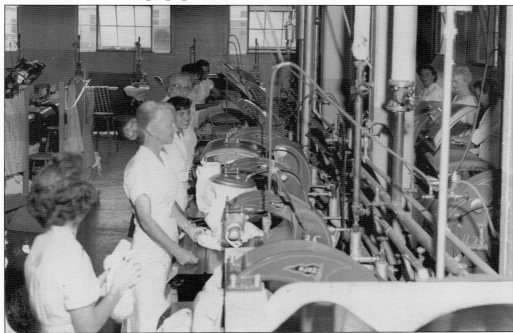

There were plenty of jobs making the Camarillo State Hospital a major area employer, including pressing the many white hospital uniforms.

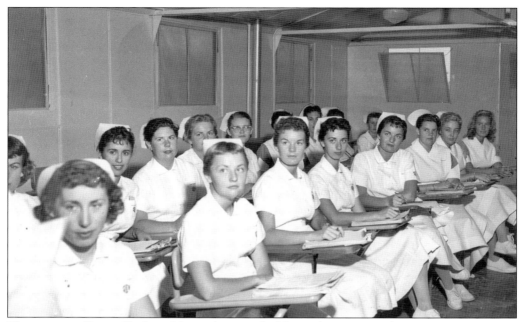

The nurses at Camarillo State Hospital received additional training at the site.

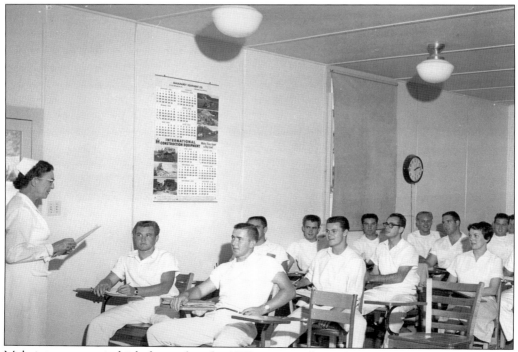

Male interns were in high demand in the 1950s, as were flattop haircuts.

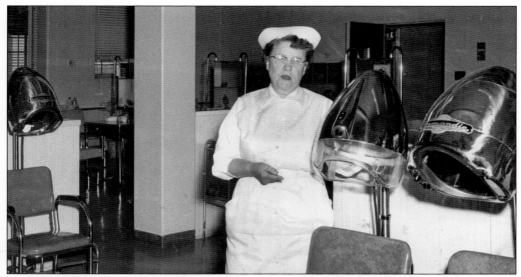

Another service at the Camarillo State Hospital was a state-of-the-art beauty salon.

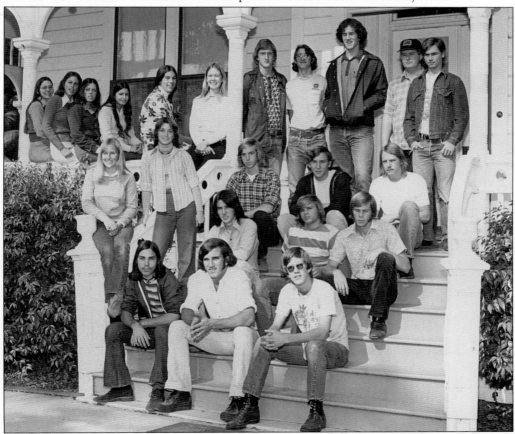

Student leaders from Camarillo High School sport the fashions of 1973 on the steps of the Adolfo Camarillo home.

Seven

CAMARILLO HORSES

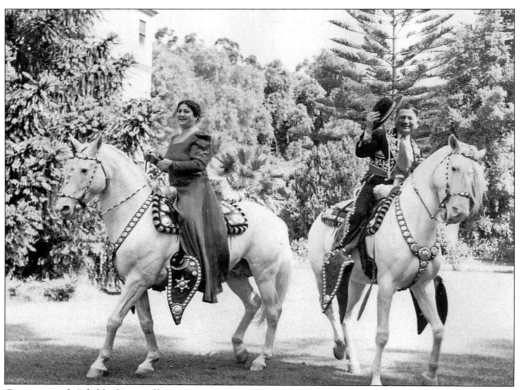

Carmen and Adolfo Camarillo are pictured on the world-famous Camarillo white horses. In 1921, Adolfo purchased a nine-year-old Arabian horse at the Sacramento State Fair that he named Sultan. He brought the horse back to his ranch to start a lineage of horses that have been a part of many of California's major groundbreaking ceremonies and parades. Sultan was bred with Morgan mares under the tutelage of Meliton Ortiz. The horses stayed in the Camarillo family up to the time of the passing of Carmen in 1987, at which time the horses were sold at a public auction.

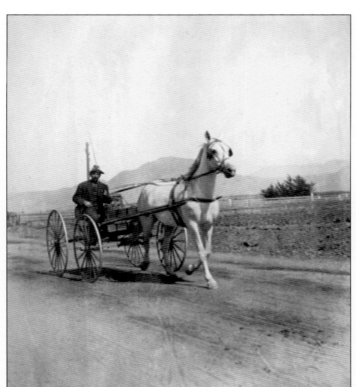

Erastus Wright Daily takes a stroll with his white horse, *c.* 1910.

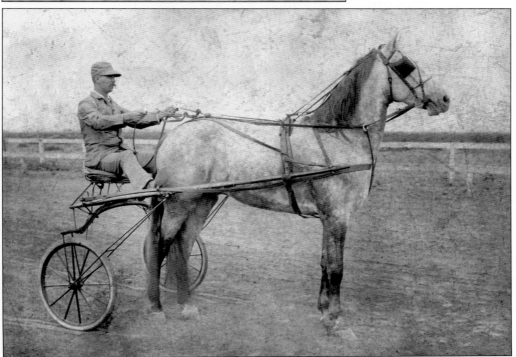

H. M. Stanley readies Michael Flynn's racehorse for a race at the Hueneme racetrack, *c.* 1895.

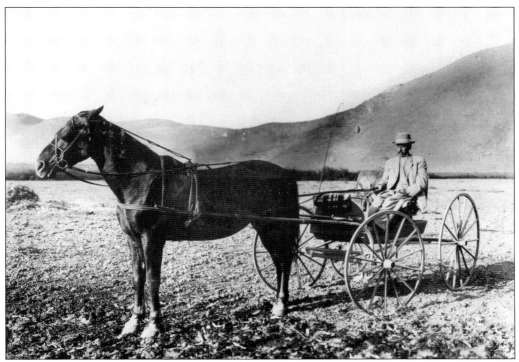

Joseph Lewis takes a carriage ride with his black horse.

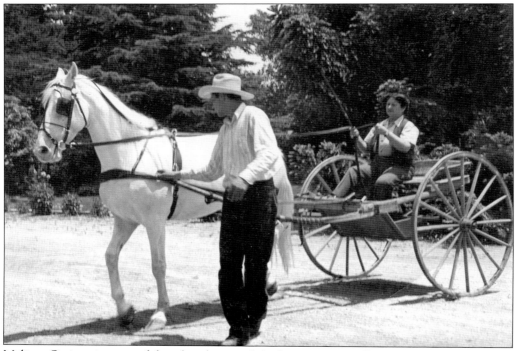

Meliton Ortiz trains one of the white horses while Carmen Camarillo tends to the reins.

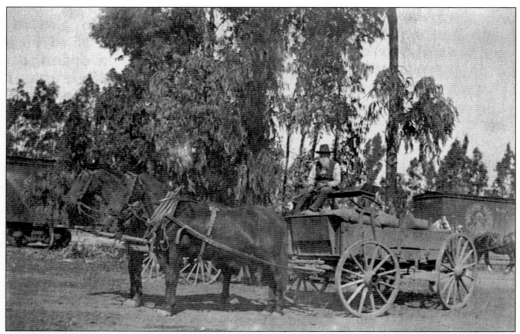

John Mahan straps two horses to his spring wagon for a trip to the new town of Camarillo, *c.* 1905.

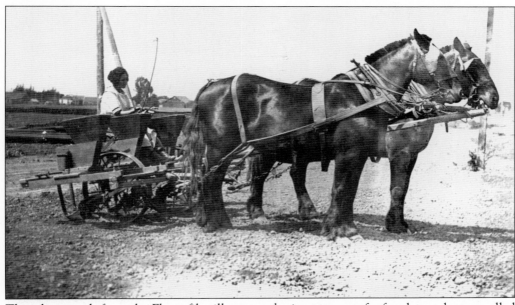

This photograph from the Flynn files illustrates the importance of a four-bean planter, pulled here by two Percheron horses.

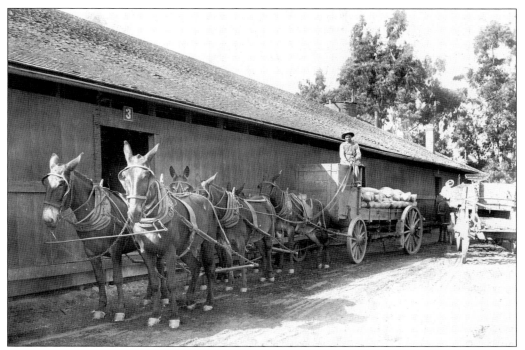

An six-mule team is pictured behind a shed at the Flynn ranch, *c.* 1910. (Courtesy Mary Caroline Chunn.)

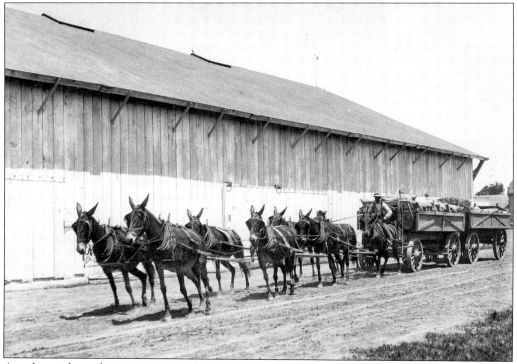

Another eight-mule team is pictured at the Somis ranch. (Courtesy Betty Culbert Powell.)

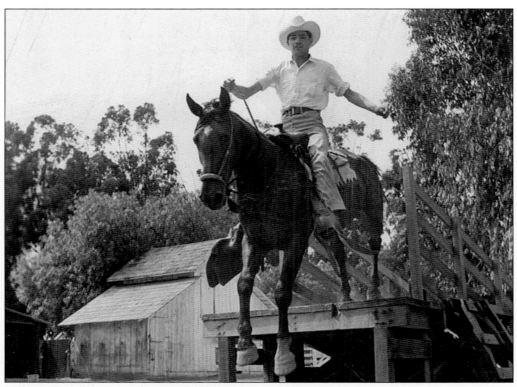

Meliton Ortiz was not only a top rider, but also a great trainer.

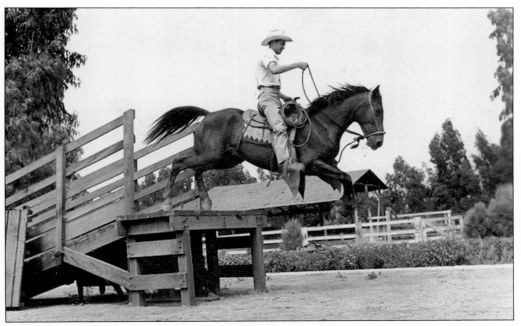

Meliton worked for the Camarillo family for nearly 60 years.

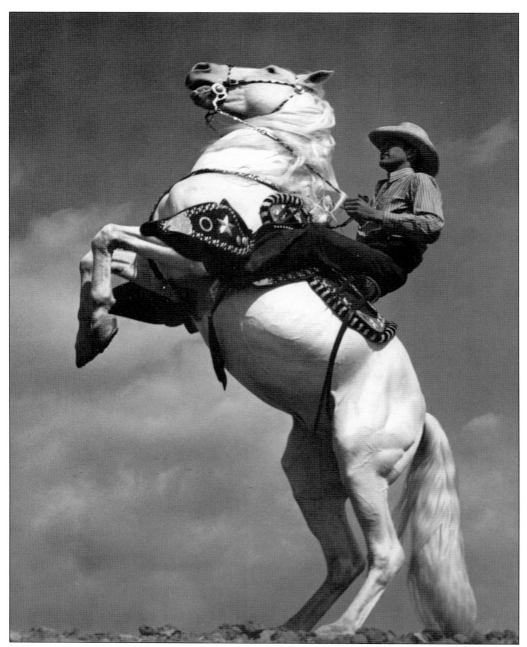

Meliton Ortiz, pictured here training Diamonte, first met Adolfo Camarillo when Meliton was 11 years old, walking home from school. Camarillo asked the barefoot boy if he wanted to ride a pony. Shrugging his shoulders, Camarillo drove Ortiz to the stables and had the foreman get a pony. After a few tries and getting bucked off, the young Meliton went home. He came back the next day and the day after that until no pony or horse could buck off the future caretaker of the Adolf Camarillo horses.

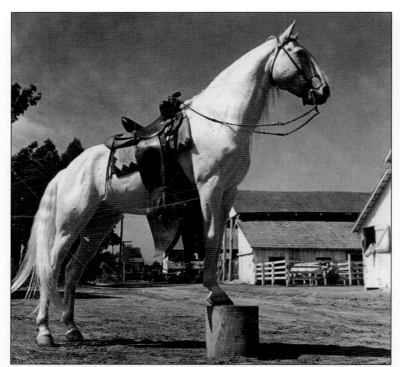

Diamonte was from the first generation of horses to be fathered by Sultan, Adolfo Camarillo's original white horse. Adolfo never sold one of his Arabian-Morgan white horses.

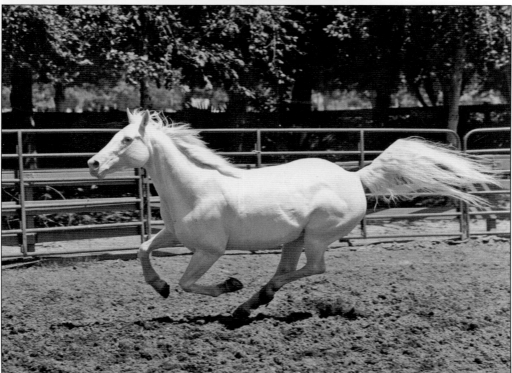

Panchito was from the third generation of Arabian-Morgan horses.

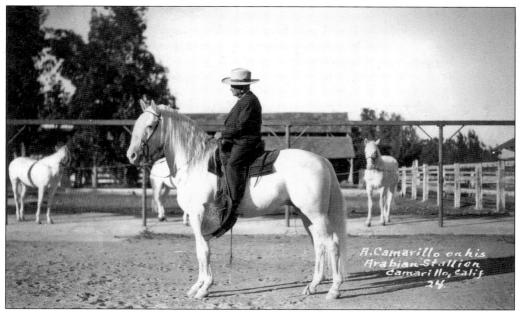

The accomplishments and generous contributions of Adolfo Camarillo are worthy of a stand-alone book. One of his more astounding accomplishments was the 56 years he dedicated to the education of students by serving on the board of the Pleasant Valley School District, from 1895 to 1950.

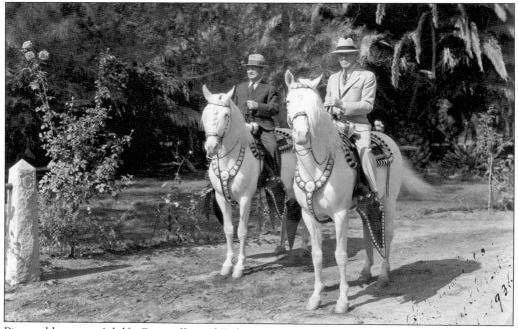

Pictured here are Adolfo Camarillo and Robert Clark. Clark, born in Wisconsin in 1876, came to Ventura County by 1881. He was raised in the Ojai area and, by 1922, was elected sheriff. His wife, Alice Burnett, is a descendent of the great Confederate Civil War general, Robert E. Lee. The Clarks raised five sons and five daughters.

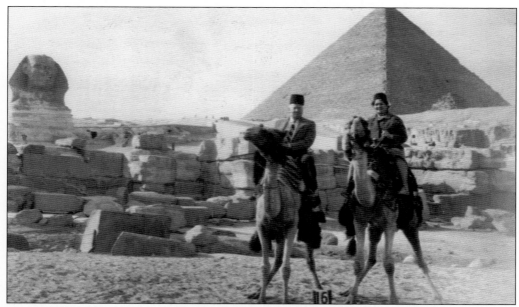

Unable to find a white camel to ride, Roy Jones and Carmen Camarillo Jones mount a traditional camel for this pose in front of the Egyptian sphinx in 1966.

Carmen Camarillo Jones sent the pyramid postcard to her cousin, Florence Obiols Maulhardt and her husband, Ed, in Camarillo.

Carmen Camarillo Jones carried on the family's tradition of riding the white horses in local parades, a practice which spanned 70 years.

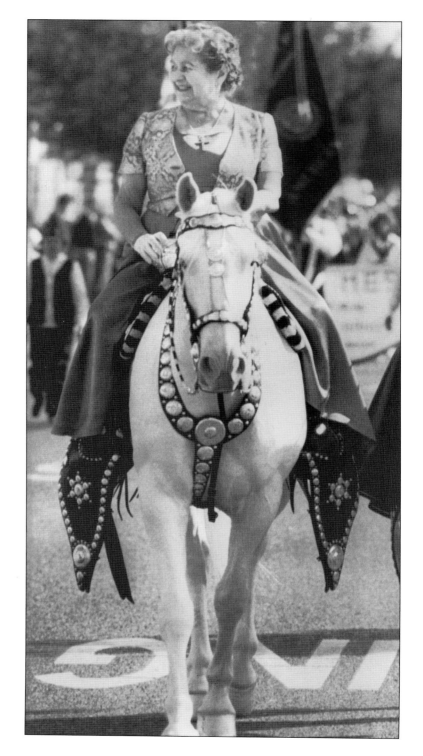

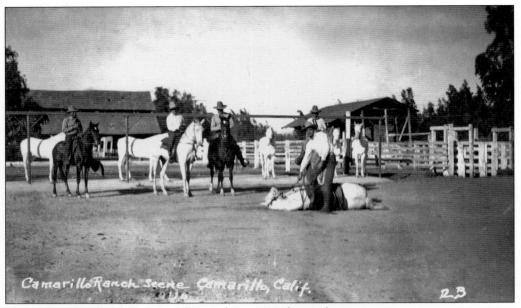

In this 1940s postcard, "a Camarillo ranch scene" is featured.

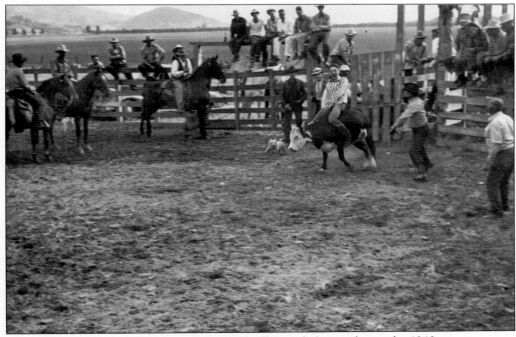

The local cowboys gather at the Adolfo Camarillo ranch for a rodeo in the 1940s.

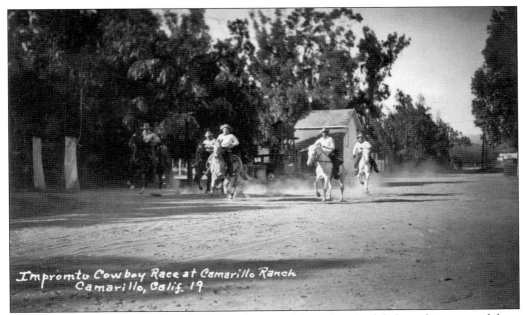

An "impromptu cowboy race at the Camarillo Ranch" is what the label on this postcard from the 1940s reads. The Camarillo Ranch postcards are courtesy of Meliton Ortiz, who is also pictured in each postcard.

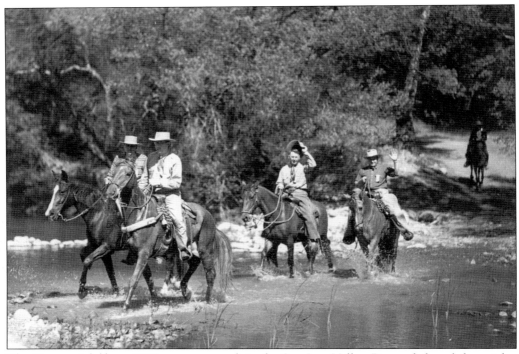

The Campo Adolfo, *c.* 1946, crosses a creek in the San Inez Valley. Pictured, from left to right, are Robert Maulhardt, Paul "Tex" Talbert, Edwin Carty, and Edward "Hap" Maxwell.

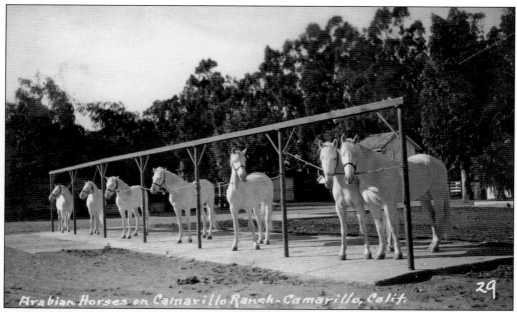

In this *c.* 1950 postcard, Arabian horses are pictured at the Camarillo Ranch.

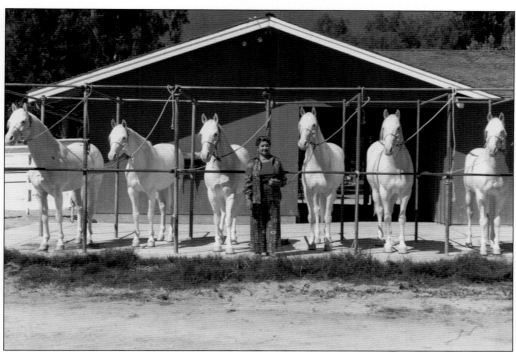

Carmen Camarillo Jones poses at the Camarillo Ranch with the white horses. Carmen requested in her will to have the horses auctioned off. She passed away in 1987, and the family fulfilled her request.

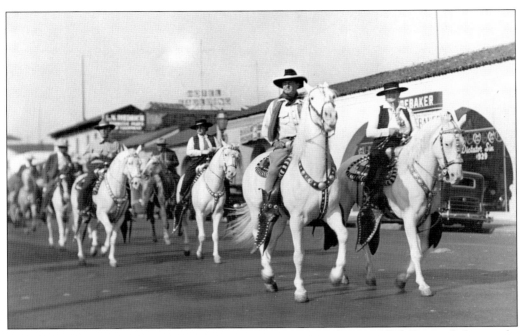

The white horses ride in the Christmas parade in Santa Barbara in 1935. Pictured, from right to left, are Gloria Petit riding Diamonte, Frank Camarillo riding Baracho, Carmen Camarillo riding Don Francisco, and Alfred Petit.

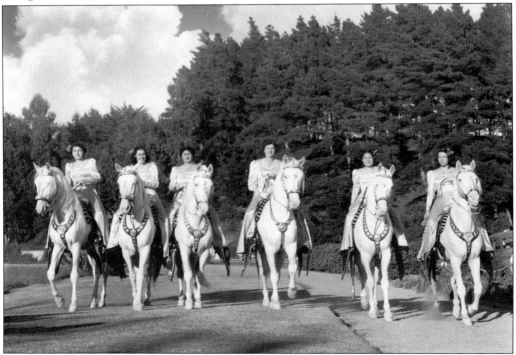

Pictured, from left to right, are Paquita Burket Parker, Rosa Lopez, Carmen Camarillo, Helen Borchard, Susana Burket Lamb, and Ileana Pezzi.

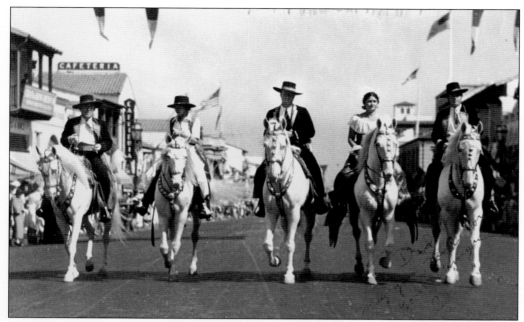

The lower, right-hand corner inscription reads, "To Dad, May you never forget your amigos, Carmen." Riders, from left to right, are Alfred Petit, Evelyn Obiols, Roy Jones, Carmen Camarillo, and unidentified.

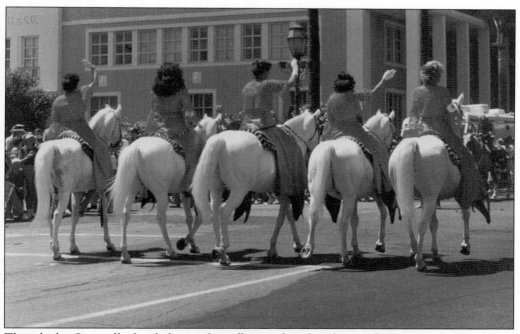

Though the Camarillo family has said goodbye to the white horses that it was associated with for 65 years, the tradition of parading the horse has continued. This photograph from the 1980s was taken at the Rose Parade in Pasadena.

Eight

A FEW
MORE PHOTOGRAPHS

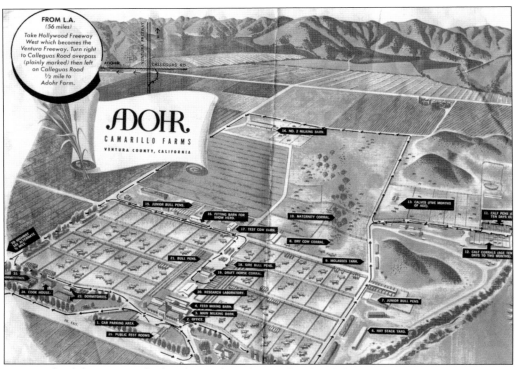

A map of Adohr Farms, which is located on the south side of Pleasant Valley Road, is pictured c. 1960. At one time, the dairy boasted milking 1,500 cows daily—"Adohr Holstein Milk for Adohr-able Babies."

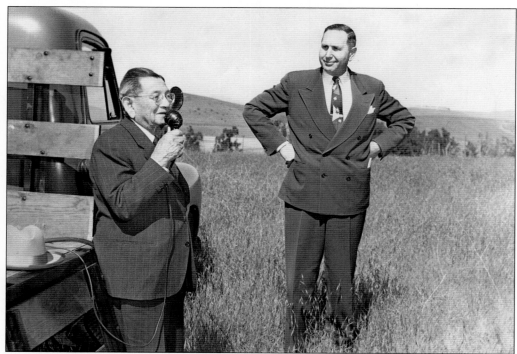

Adolfo Camarillo and school superintendent L. A. Wiemers are at the groundbreaking ceremony for Adolfo Camarillo High School, which was established in 1956.

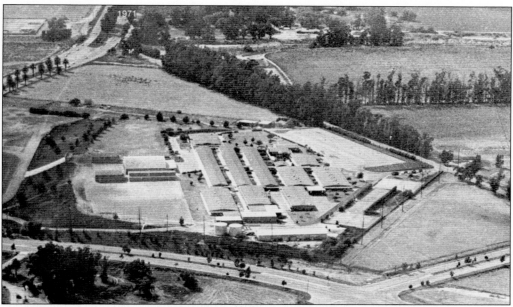

Adolfo Camarillo High School was once part of the Camarillo's Rancho Callegueas property, with farming continuing on land surrounding the school. Today the sprawling community of Mission Oaks has replaced the farmland.

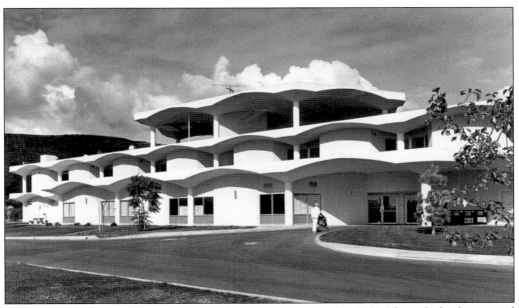

The Pleasant Valley Hospital on Antonio Avenue was completed in 1974. Through the determined efforts of Bob Kildee and others, it took 13 years to bypass all the obstacles for the hospital to open its doors.

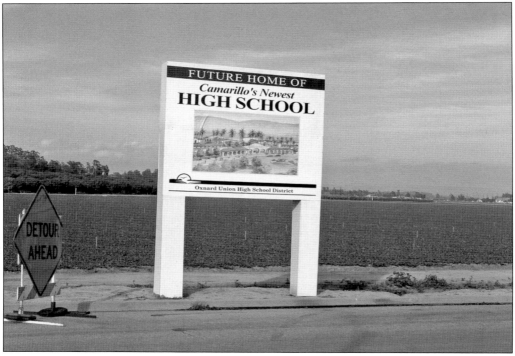

To the northeast of the hospital, Camarillo looks to add its second high school—50 years after the construction of Adolfo Camarillo High School.

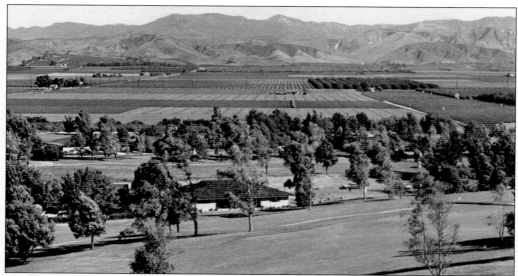

The Las Posas Country Club was designed by Lawrence Hughes and opened in 1958. Over the years, many golf pros and movie stars have played at the course. Among the most celebrated is golf pro Corey Pavin, who hosts an annual event at the course to raise money for Big Brothers/Big Sisters of Ventura County.

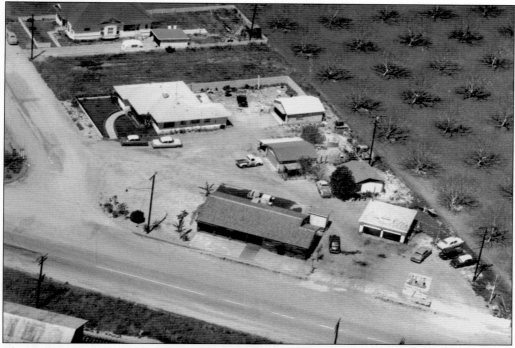

This 1956 aerial view shows El Tecolote Restaurant off Lewis Road. In 1946, El Tecolote (The Owl) was started in Moorpark by Mike Loza. Loza moved the business to Camarillo in 1948 and, by 1952, relocated a few blocks to the current location. Loza sold the restaurant to Dave and Judy Jones, who continued the great food tradition into the 21st century. (Photograph courtesy of Dave Jones.)

Nine

CAMARILLO RANCH

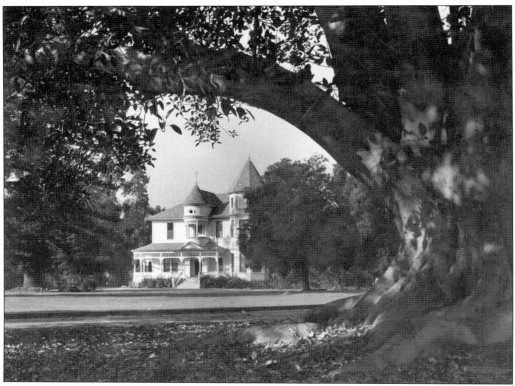

The last of the Camarillo descendants to live in the Adolfo Camarillo home was the Bert Lamb family. The Centex Corporation bought the property and deeded 4.2 acres to the city with the intention of creating a public facility for city events.

The slaughterhouse is pictured 1997, shortly before the building was slaughtered during the tear down of the Camarillo Ranch.

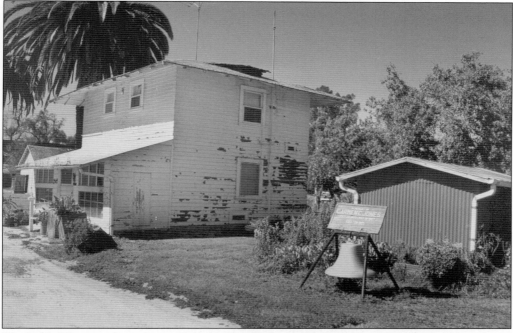

The Baker House took on a tenant who lived in the house after Adolfo Camarillo passed away and Carmen moved off the property. Originally the structure was built as a four-bedroom bunkhouse. Longtime foreman Fernando Tico was found dead from a heart attack in one of the bedrooms.

One of two small hay barns at the Camarillo Ranch is located to the north of the big barn.

The big barn, at its original location on the Camarillo Ranch, was situated to the east of the main house.

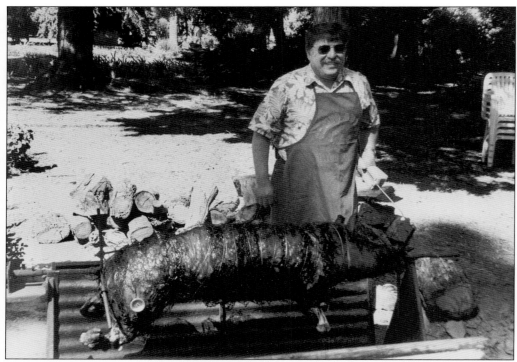

Bert Lamb, the great-grandson of Adolfo Camarillo, barbecues a pig at the last Camarillo family barbecue at the ranch in the summer of 1997.

Portions of the Rancho Calleguas are still in the hands of the Camarillo descendents. East of the Baron Brothers Nursery off Santa Rosa Road, the Lamb family grows avocados and citrus. A new variety was developed by the family, the Lamb/Hass avocado.

This 2000 view shows the relocated stables and barn at the Camarillo Ranch.

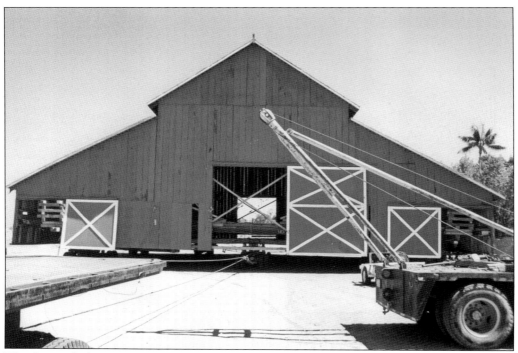

The Camarillo barn was relocated in September 1999 to a spot behind the house.

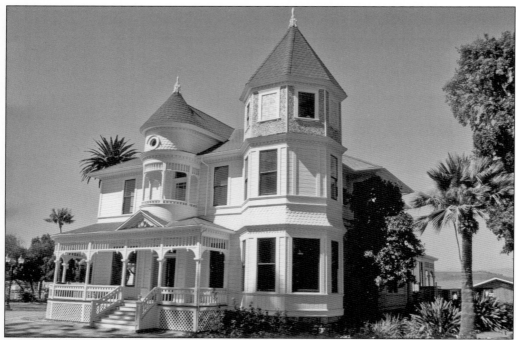

By 2000, the ranch was being utilized for social events, opening a new chapter in the history of the one the county's most prominent monuments.

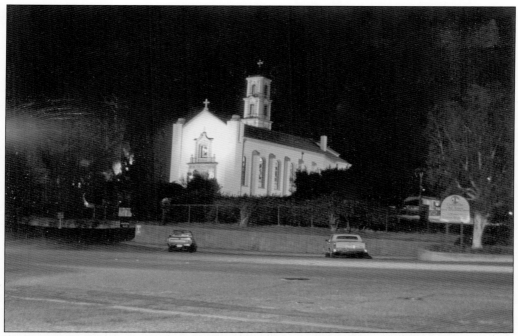

The Mary Magdalene Chapel has seen a new dawn with a renovation in 2000.

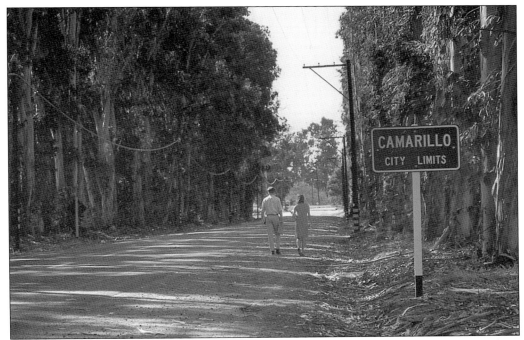

Like many communities in southern California, the city of Camarillo has said goodbye to agriculture and the eucalyptus trees that once protected the crops.

BIBLIOGRAPHY

Colbern, Robert J., and Elaine Garrett Colbern. *Biography of Franklin Hunter Garrett, M.D.* May 1993.

FitzGerald, Carmelita Marie. *El Rancho Grande: The Story of Camarillo.* Self-published as part of her Master of Arts thesis at Stanford University, 1944.

History of Santa Barbara and Ventura Counties California 1883. Thompson and West.

http://www.camarilloranch.org

http://www.camarillowhitehorses.org

Maulhardt, Jeffrey Wayne. *Beans, Beets and Babies.* MOBOOKS, 2001.

Sheridan, Sol N. *Ventura County California Vols. 1 and 2.* The S. J. Clarke Publishing Company, 1926.

Star-Free Press.

Walsh, Adele Flynn, and MOBOOKS. *Camarillo Centennial 1901–2000.* Ventura, CA: Pleasant Valley Historical Society and Clark's Printing, 2001.

White, David. *Greater Camarillo . . . Then and Now.* Camarillo Chamber of Commerce, 1978.

Ventura County Historical Society Quarterly Vol. XIV, No. 4; XIV, No. 1; XII, No. 1; XV, No. 1; Volume 46, Nos. 1–4.

www.arcadiapublishing.com

MAP SEARCH

Discover books about the town where you grew up, the cities where your friends and families live, the town where your parents met, or even that retirement spot you've been dreaming about. Our Web site provides history lovers with exclusive deals, advanced notification about new titles, e-mail alerts of author events, and much more.

Arcadia Publishing, the leading local history publisher in the United States, is committed to making history accessible and meaningful through publishing books that celebrate and preserve the heritage of America's people and places. Consistent with our mission to preserve history on a local level, this book was printed in South Carolina on American-made paper and manufactured entirely in the United States.

This book carries the accredited Forest Stewardship Council (FSC) label and is printed on 100 percent FSC-certified paper. Products carrying the FSC label are independently certified to assure consumers that they come from forests that are managed to meet the social, economic, and ecological needs of present and future generations.

FSC
Mixed Sources
Product group from well-managed forests and other controlled sources

Cert no. SW-COC-001530
www.fsc.org
© 1996 Forest Stewardship Council

Find Your Place in History.